*Winner of the*
Rebecca Smith Award
for Fine Art

# WALKING SHADOWS

## A NOVEL WITHOUT WORDS

## NEIL BOUSFIELD

MANIC D PRESS
SAN FRANCISCO

The author gratefully acknowledges Simon Brett and the Society of Wood Engravers for their encouragement and support through the Rawlinson Bequest. He also wishes to thank all those who helped, and especially his partner, Clair Randell, for her help, support, understanding, and patience.

WALKING SHADOWS ©2010 by Neil Bousfield. All rights reserved.
Published by Manic D Press. For information, contact Manic D Press,
PO Box 410804, San Francisco CA 94141    www.manicdpress.com
Printed in the USA

*Library of Congress Cataloging-in-Publication Data*

Bousfield, Neil, 1967-
 Walking shadows : a novel without words / Neil Bousfield.
   p. cm.
 ISBN 978-1-933149-29-5 (hardcover : alk. paper)
1. Bousfield, Neil, 1967- I. Title.
 NE1147.6.B68A4 2011
 741.5'973--dc22
                              2010025889

*Dedicated*
*to the memories of*

Andy Thurkettle
(1962–2006)

*and*

Rebecca Smith
(9 October 1960–10 May 1982)

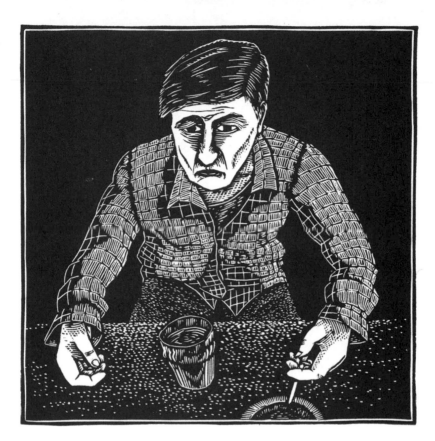

# CHAPTER
# ONE

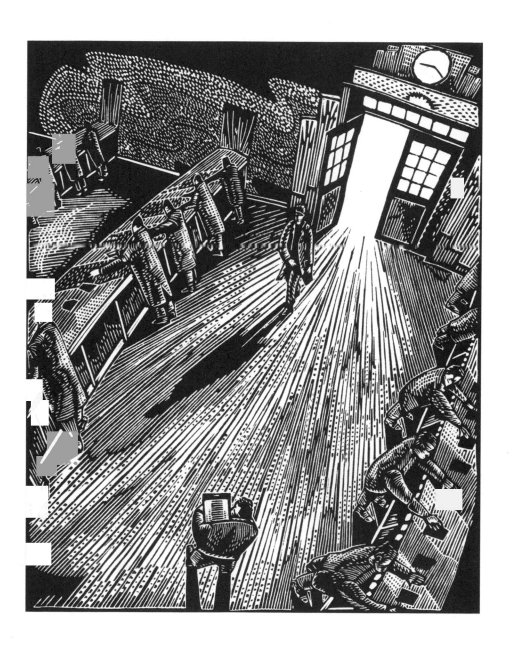

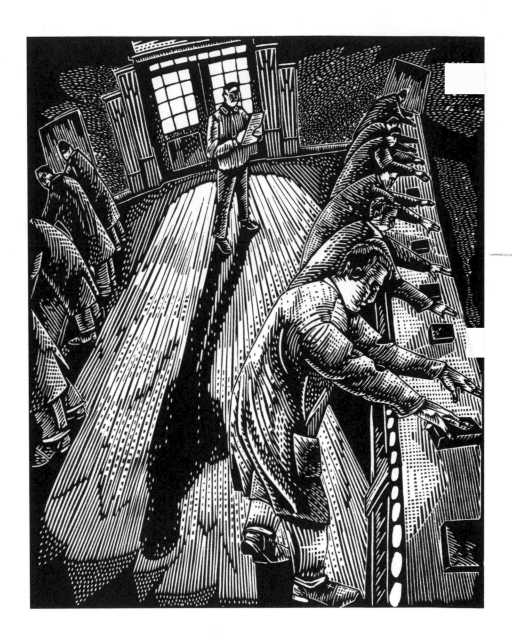

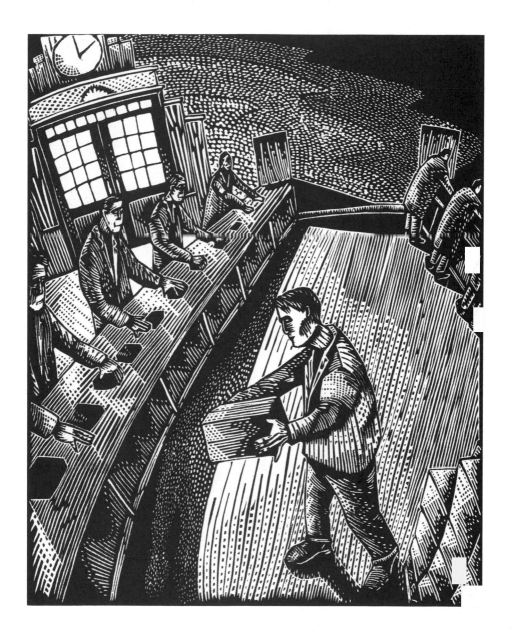

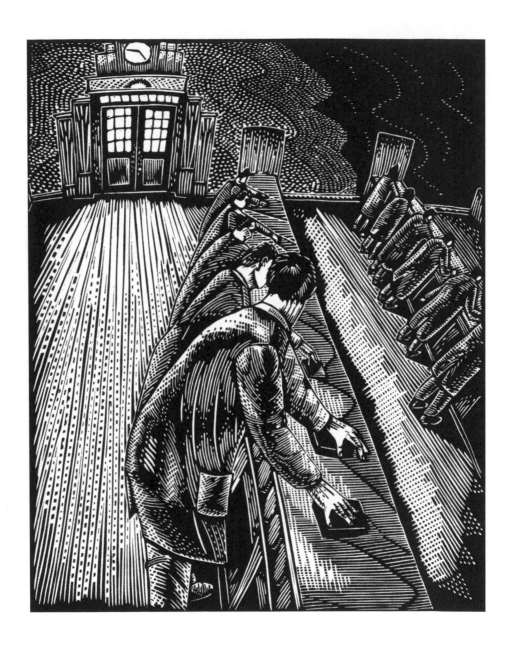

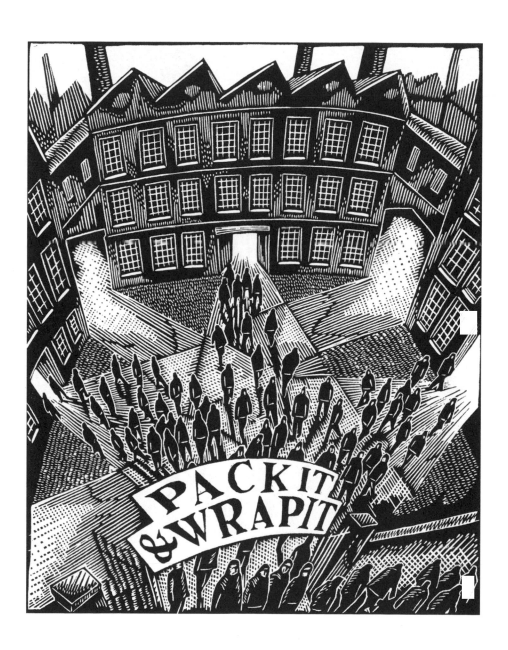

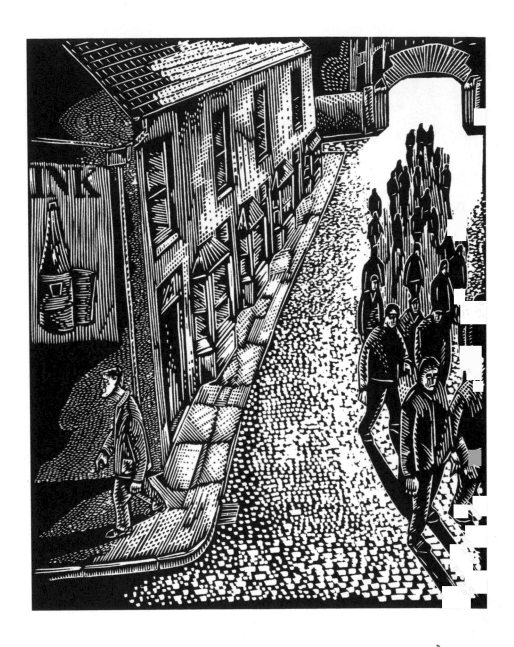

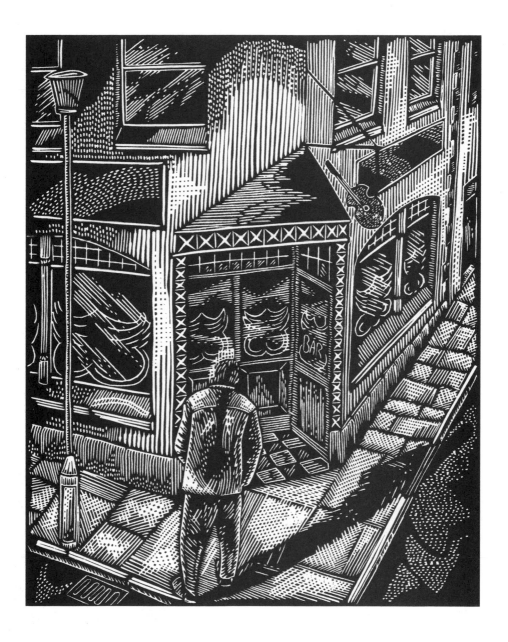

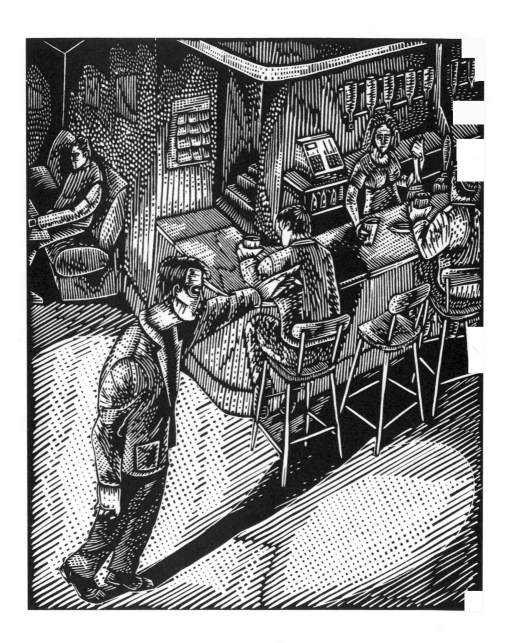

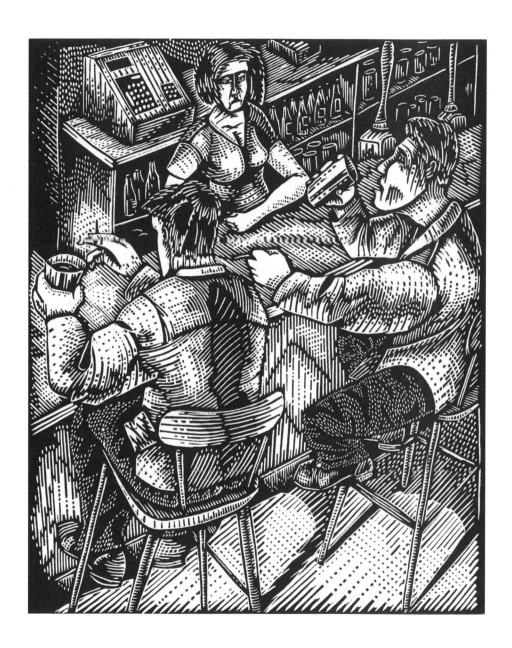

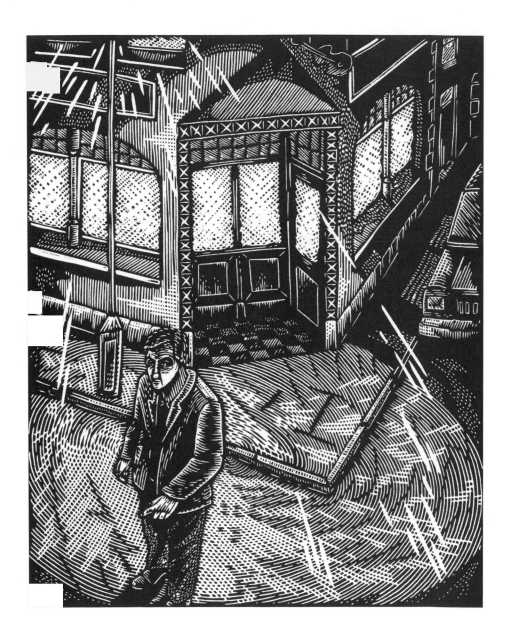

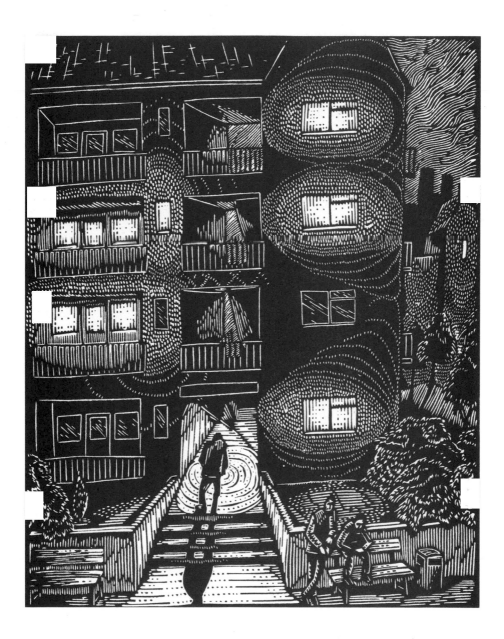

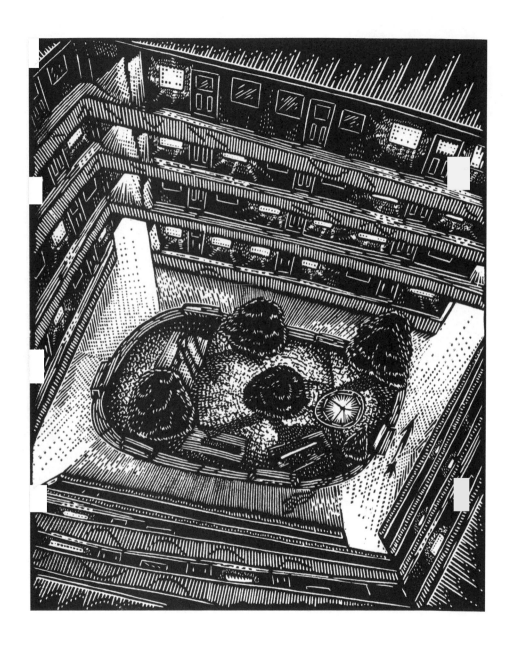

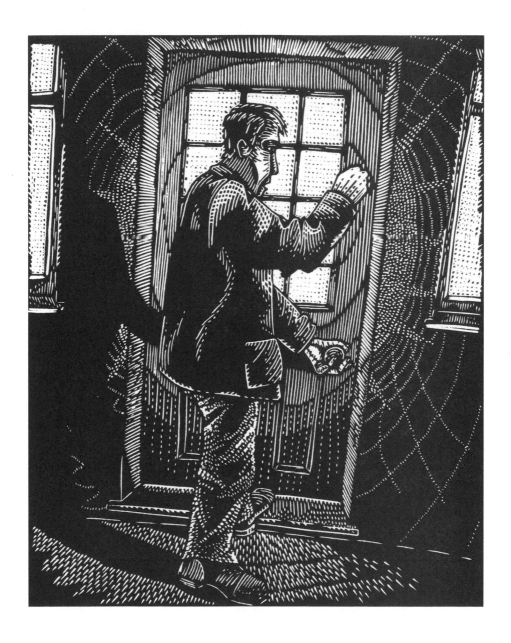

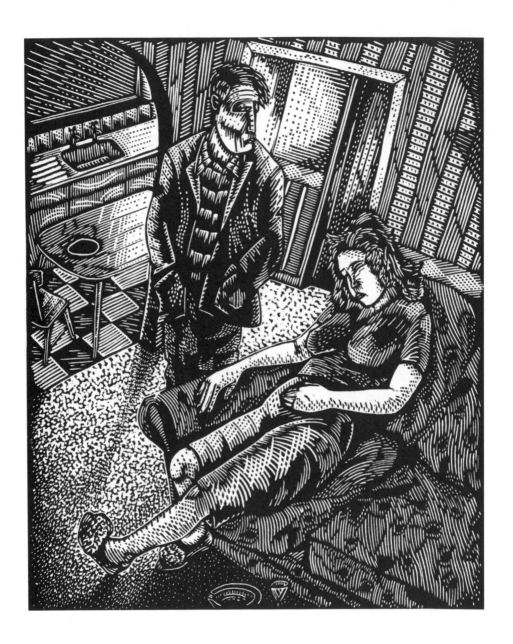

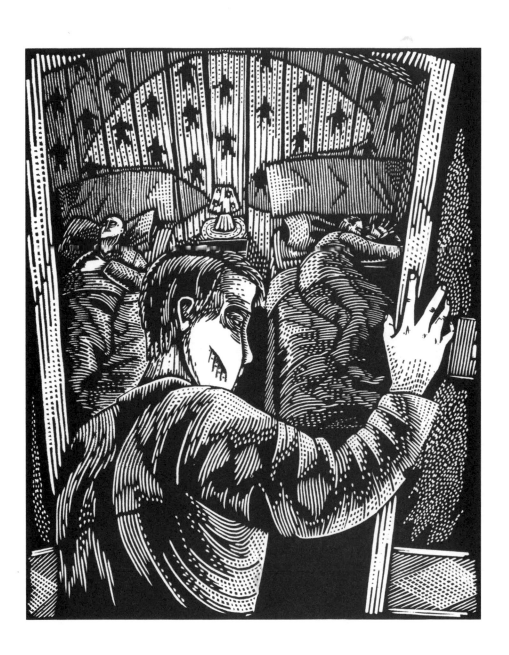

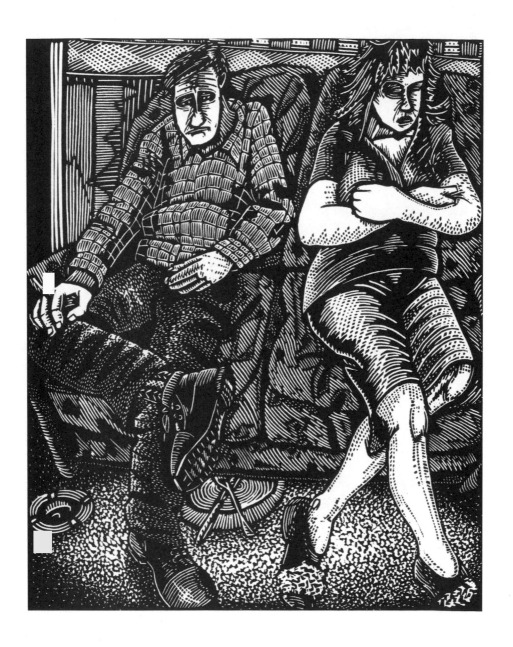

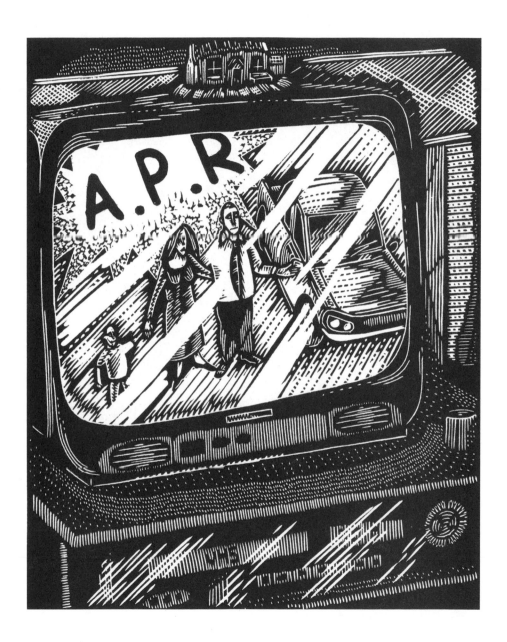

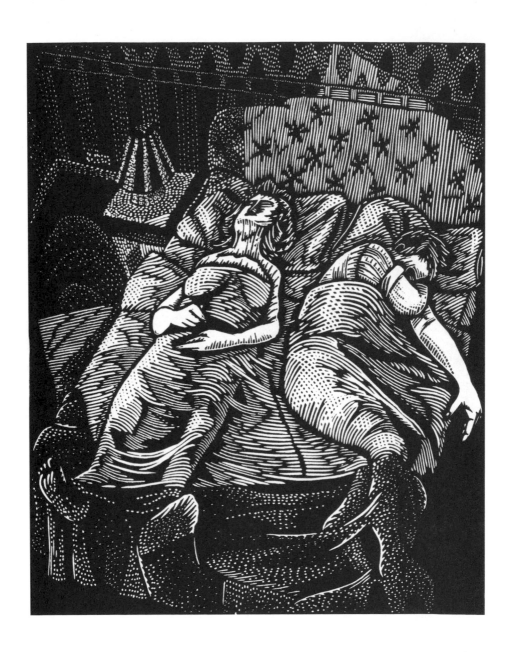

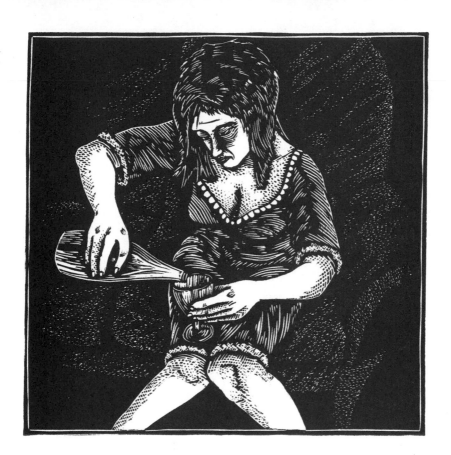

# CHAPTER TWO

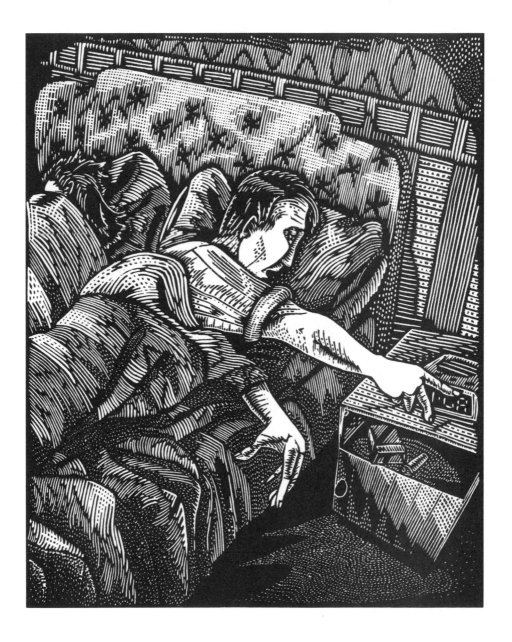

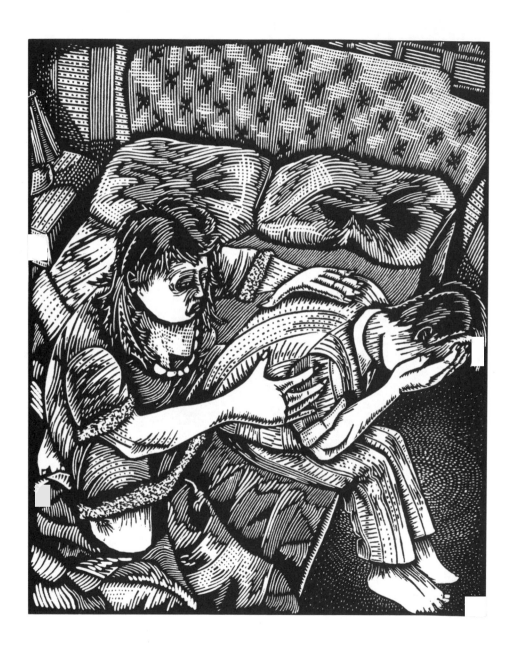

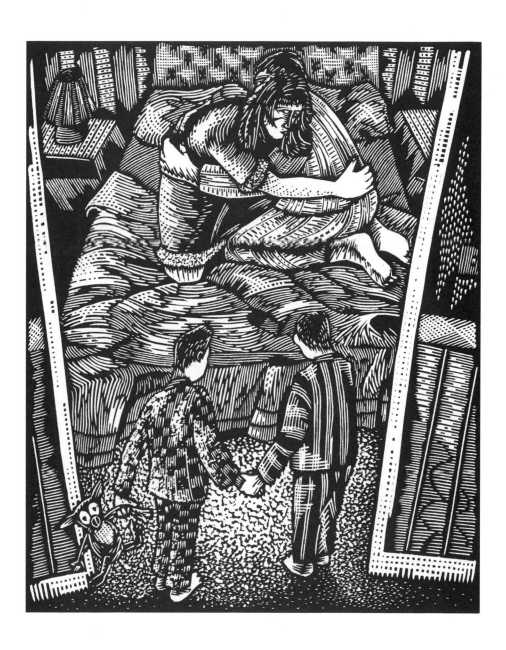

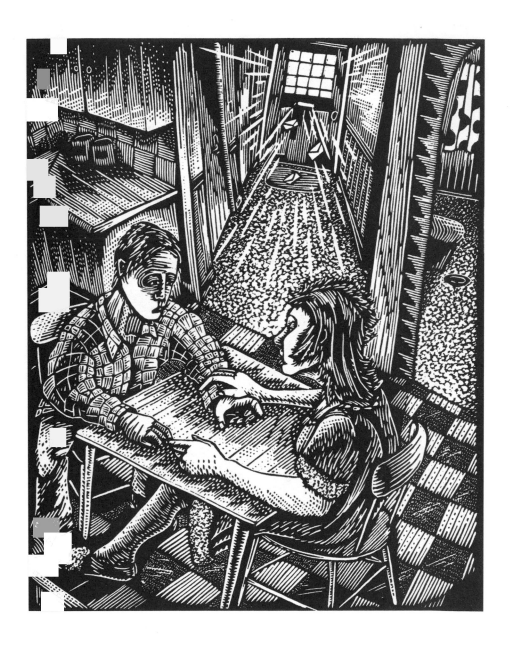

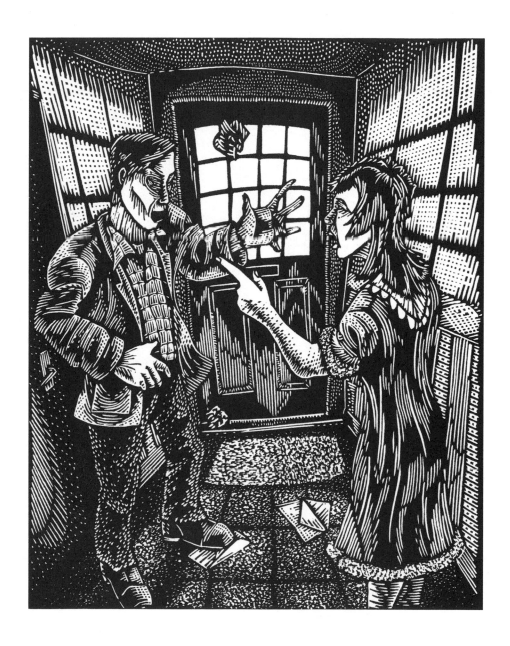

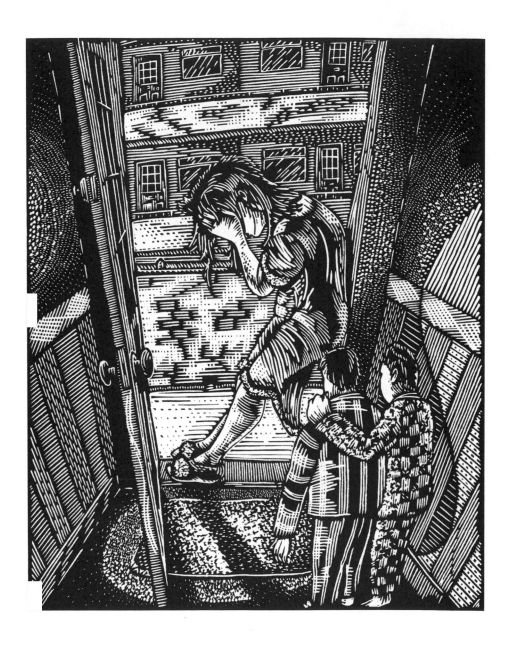

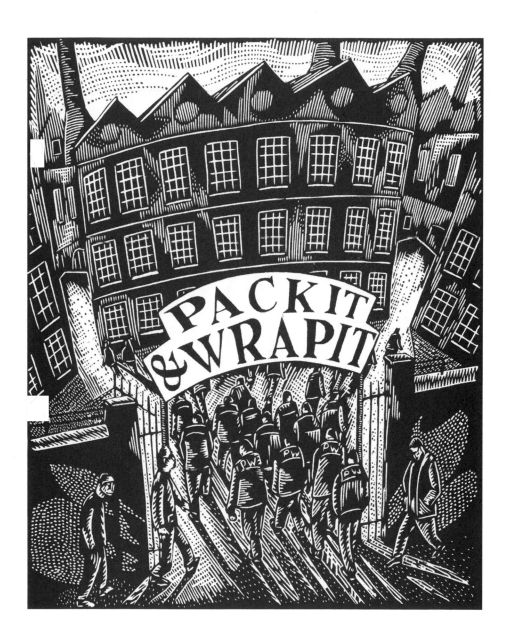

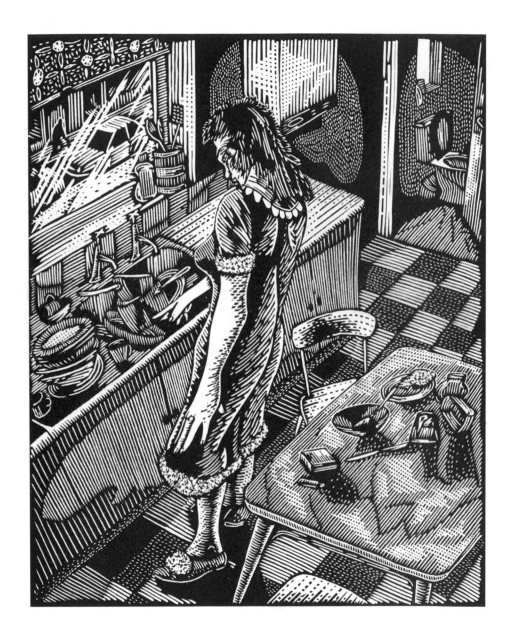

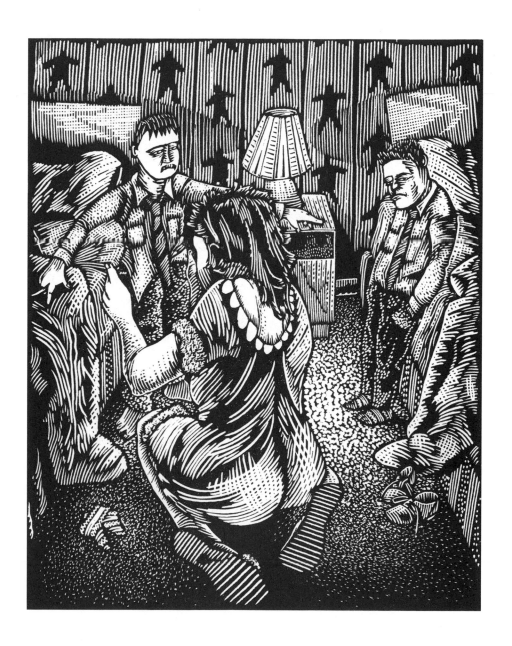

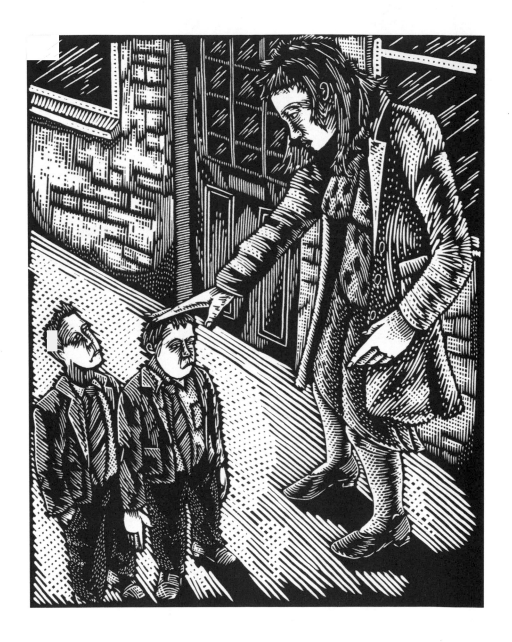

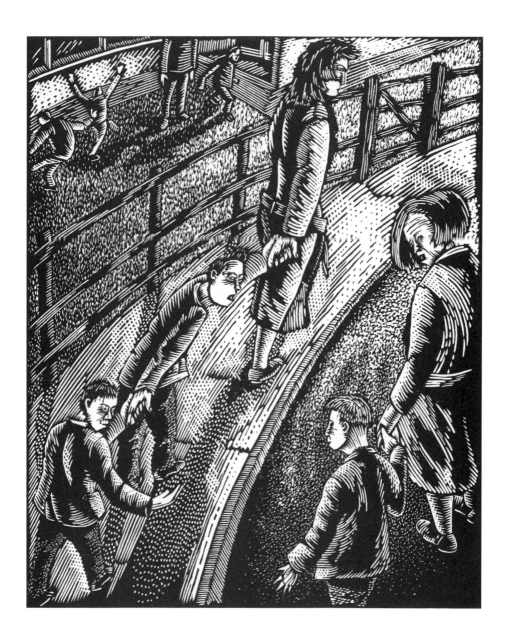

41

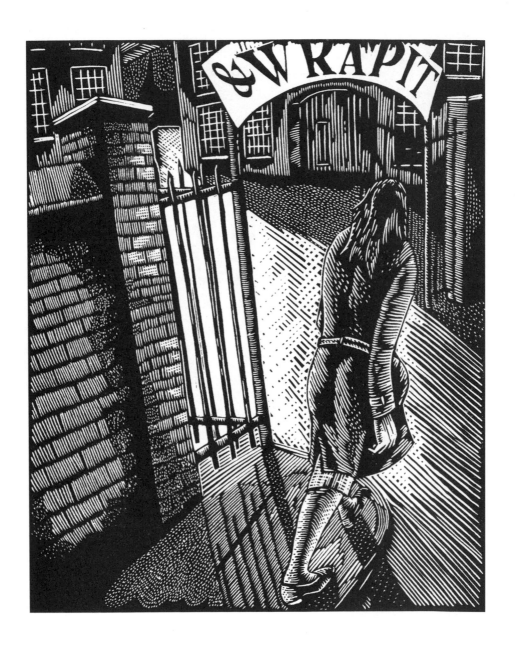

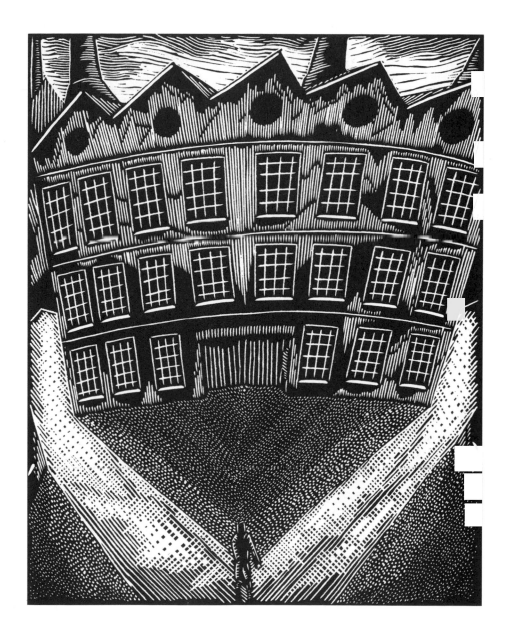

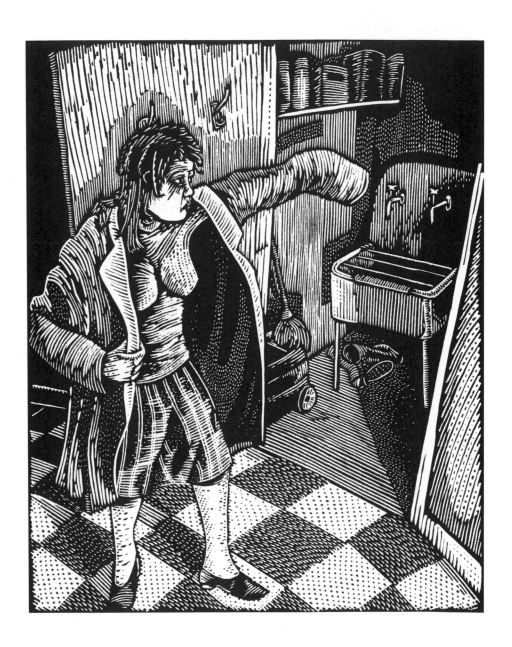

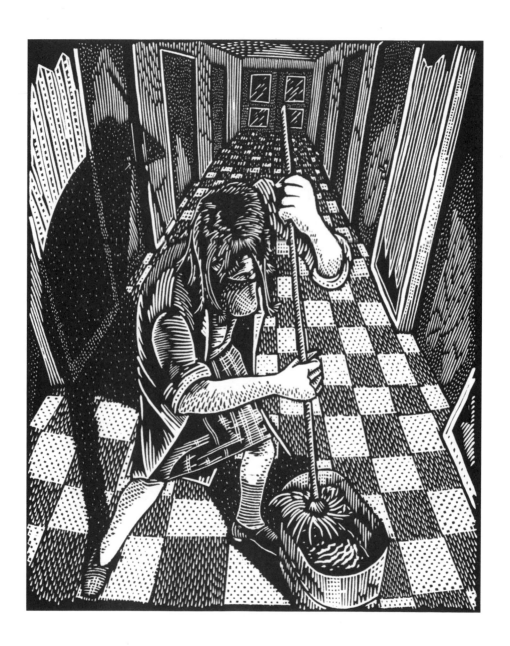

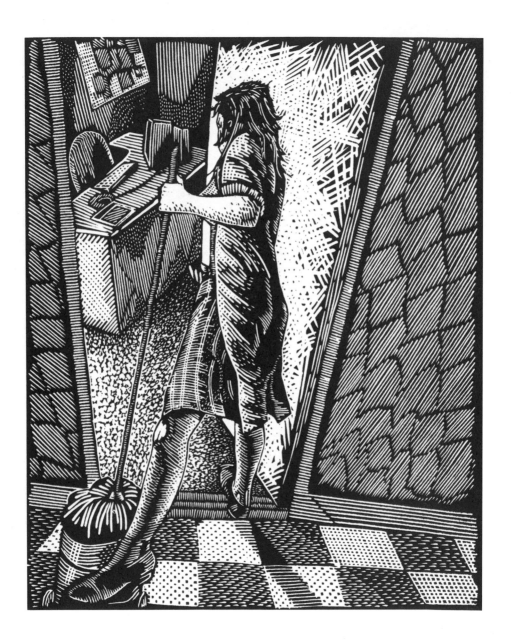

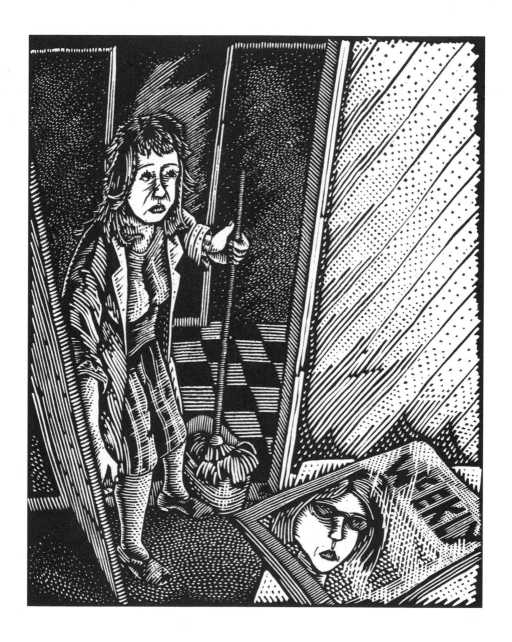

47

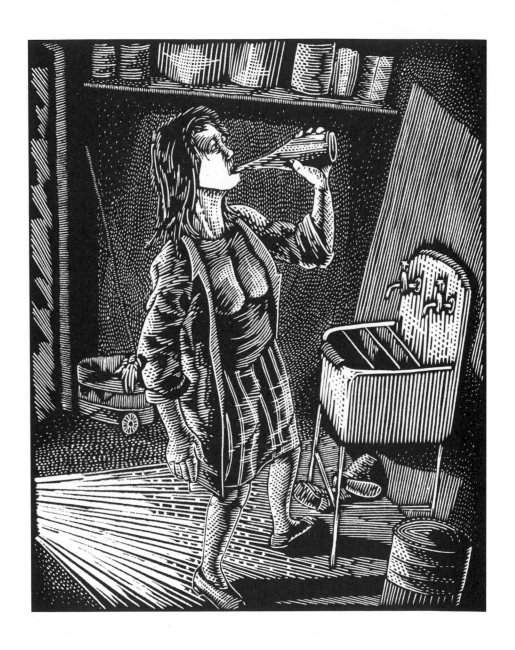

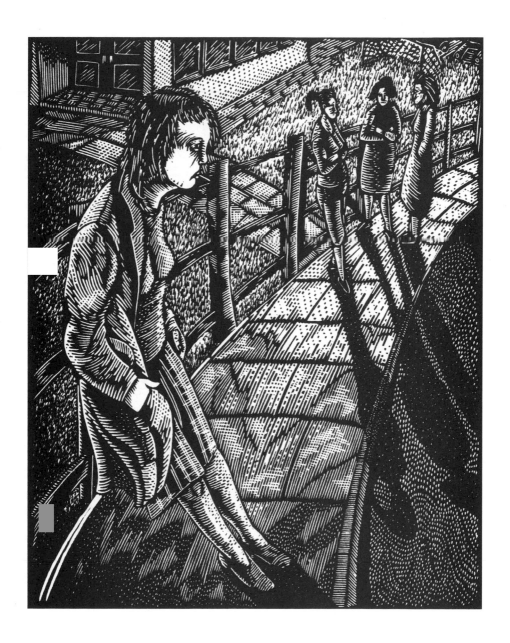

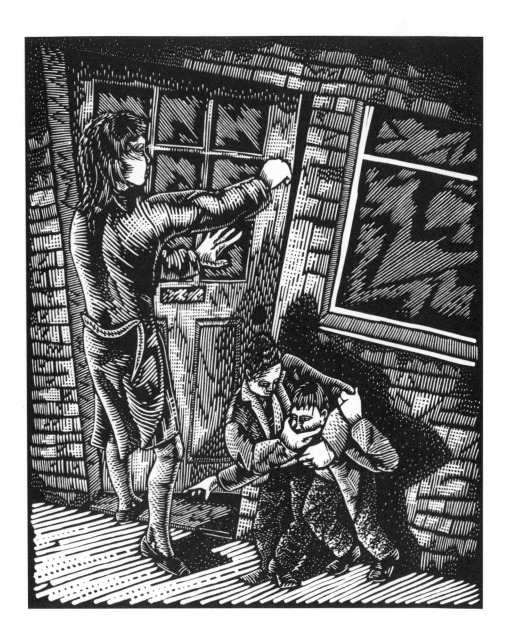

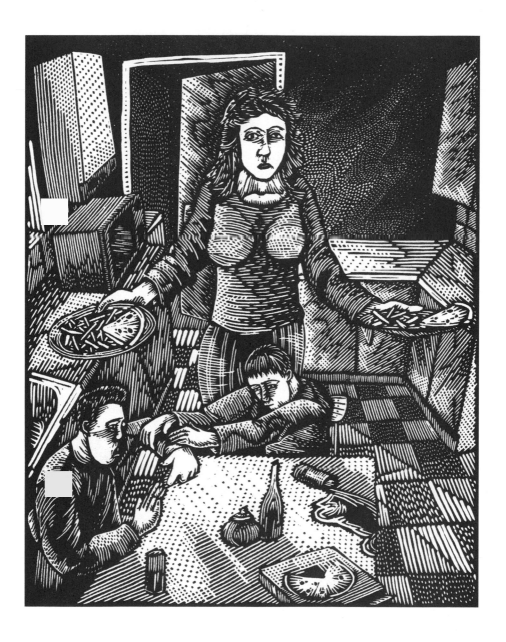

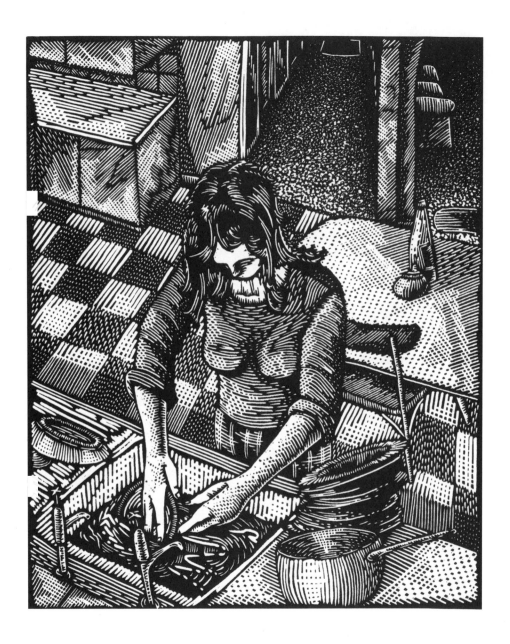

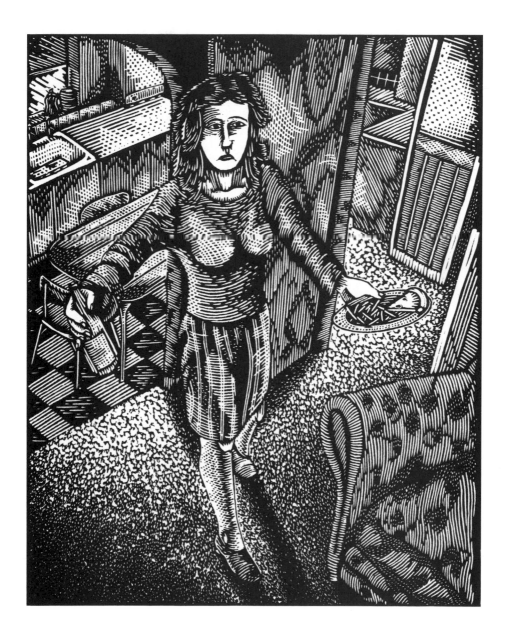

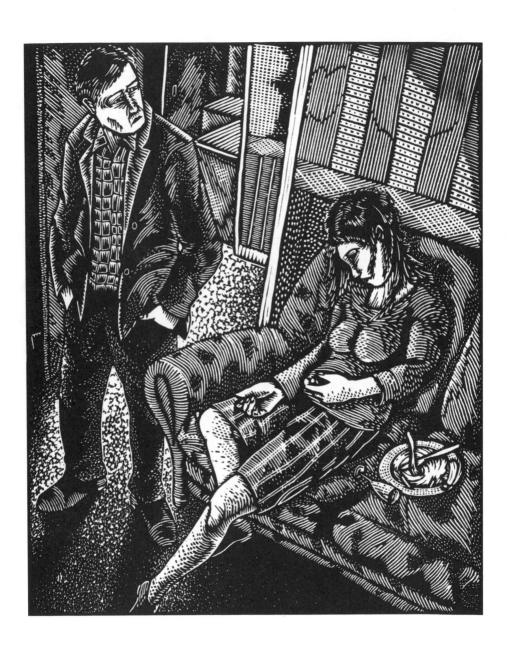

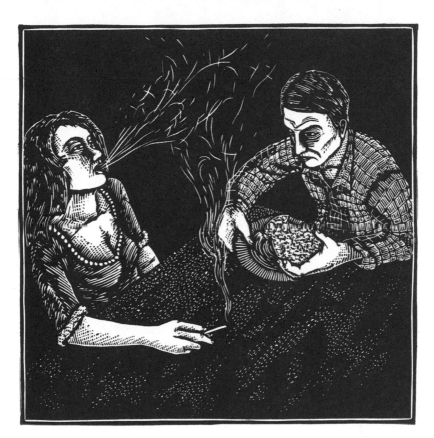

# CHAPTER THREE

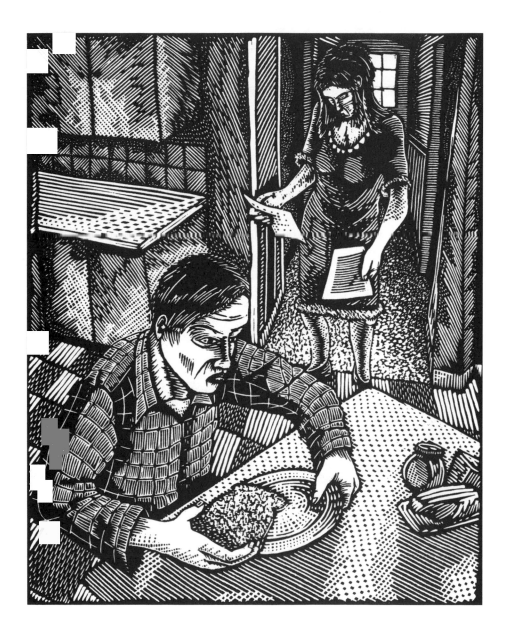

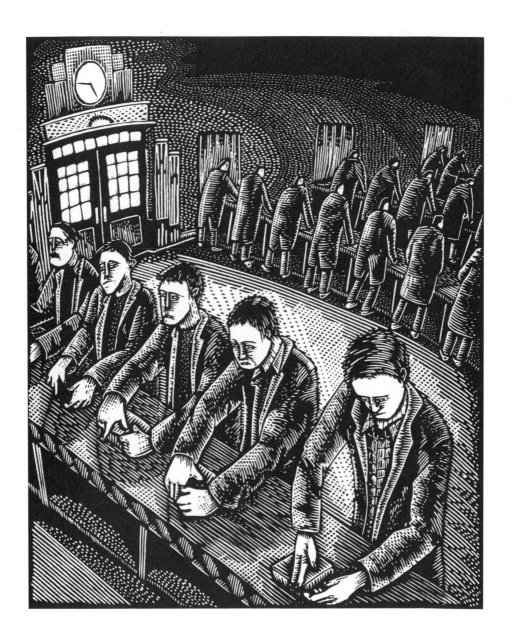

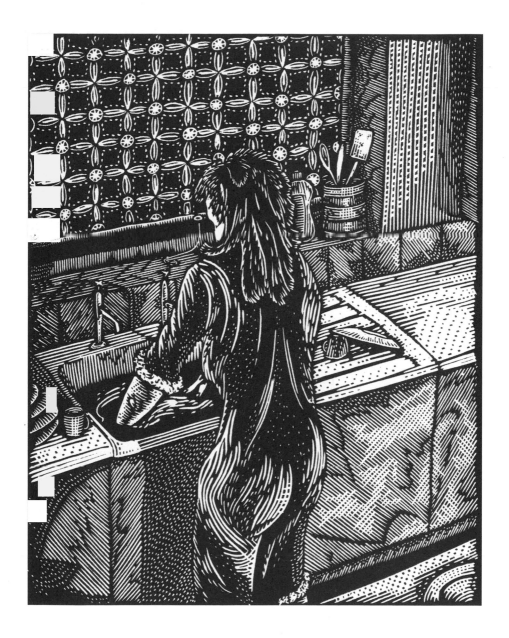

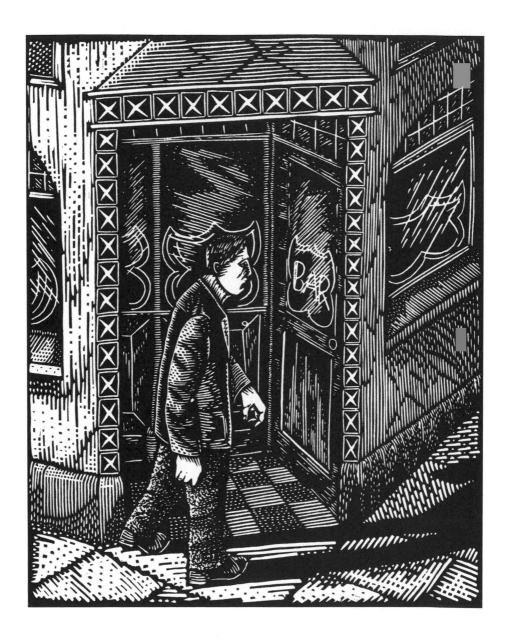

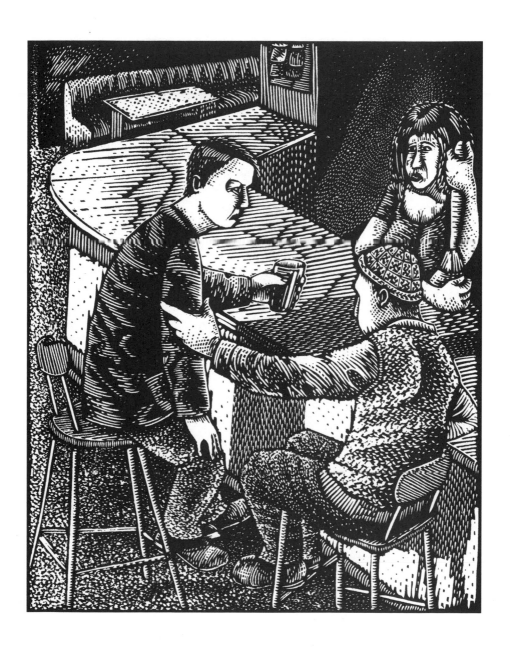

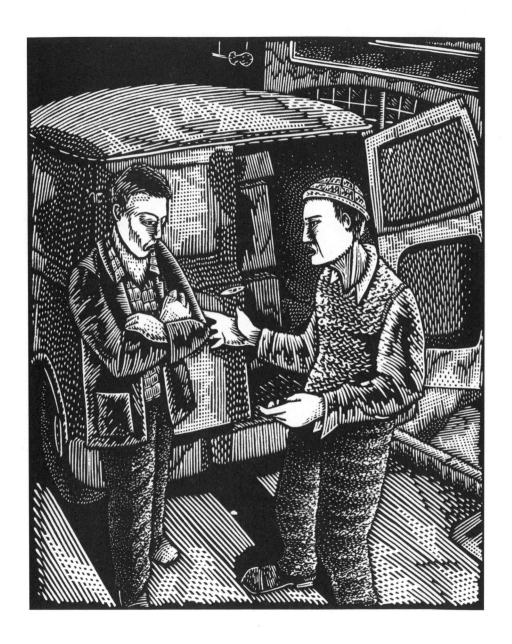

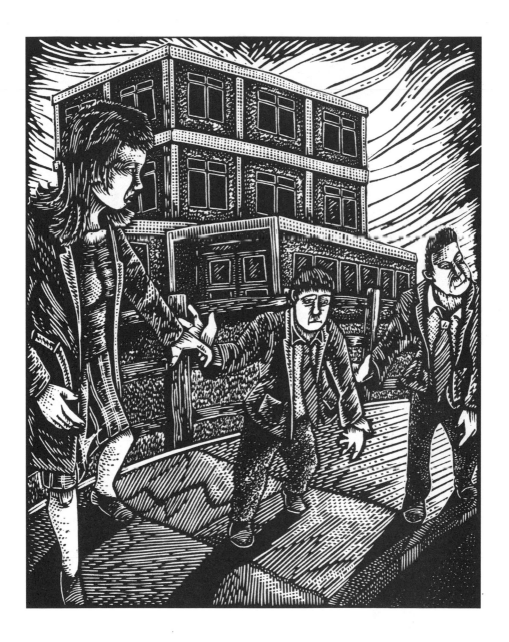

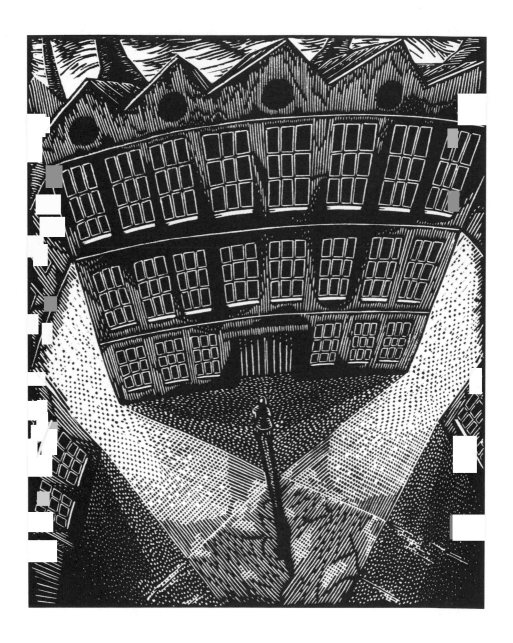

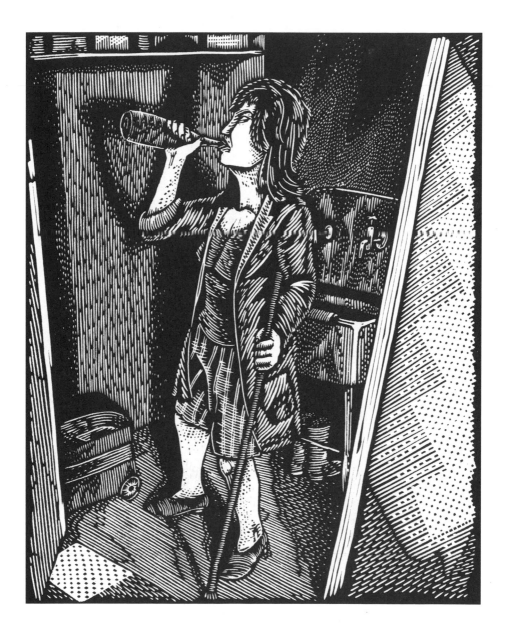

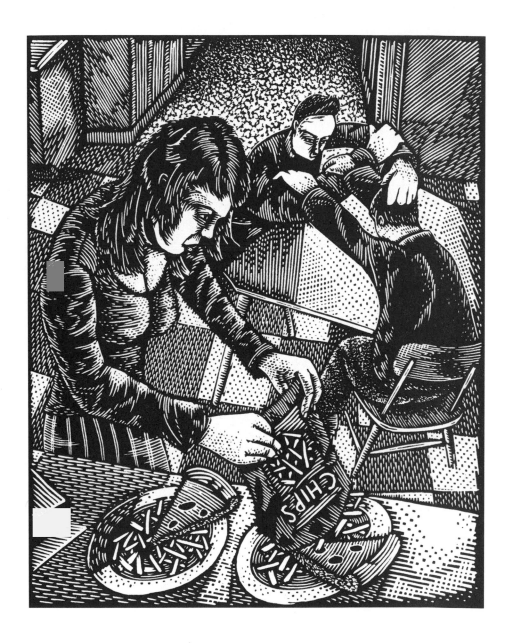

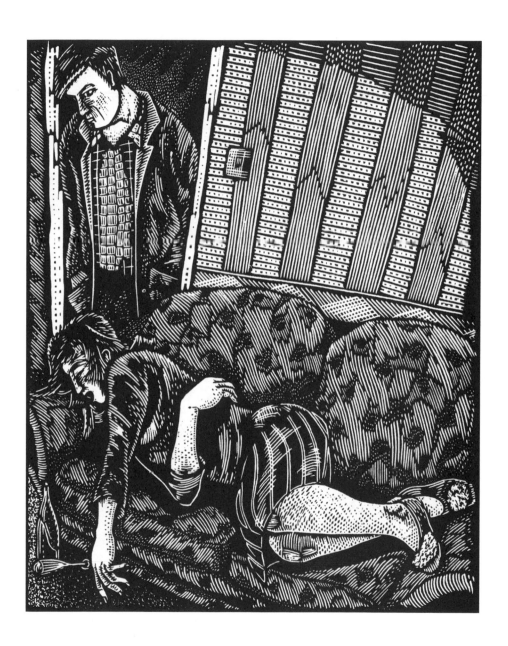

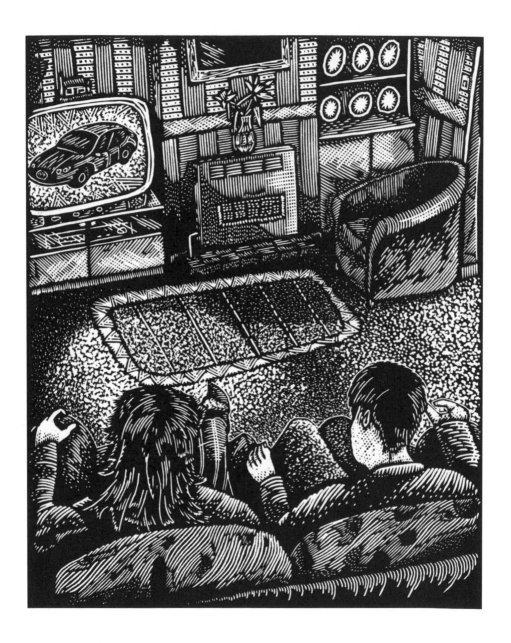

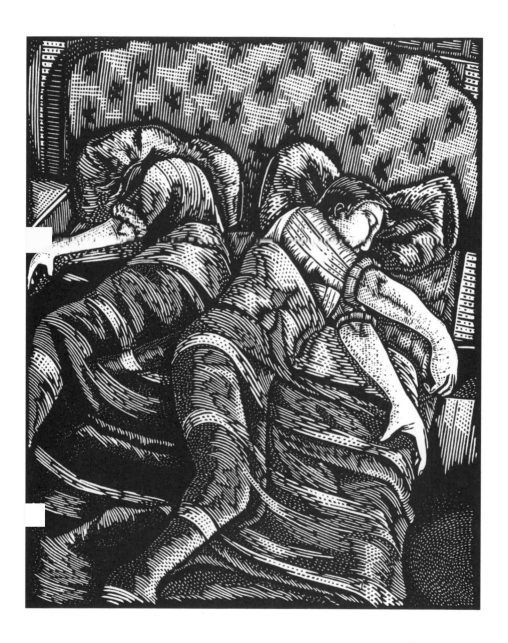

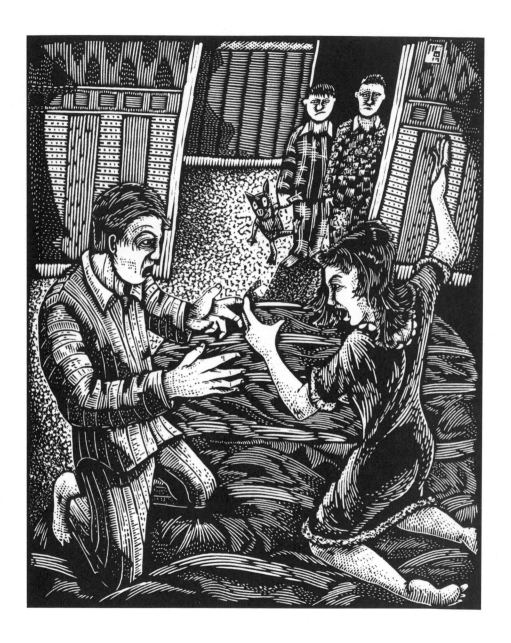

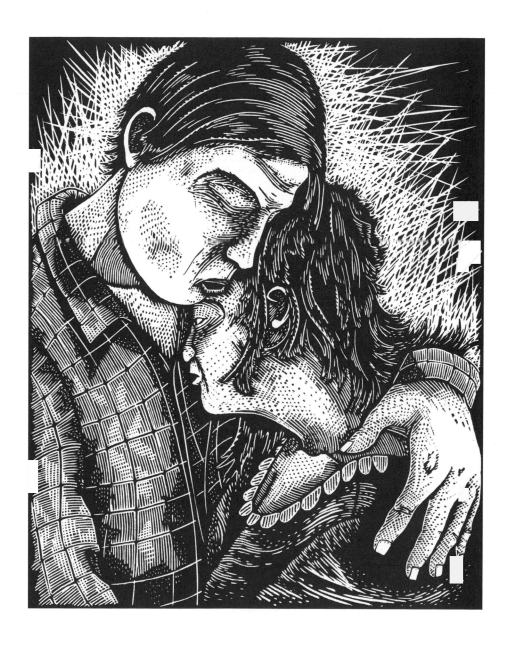

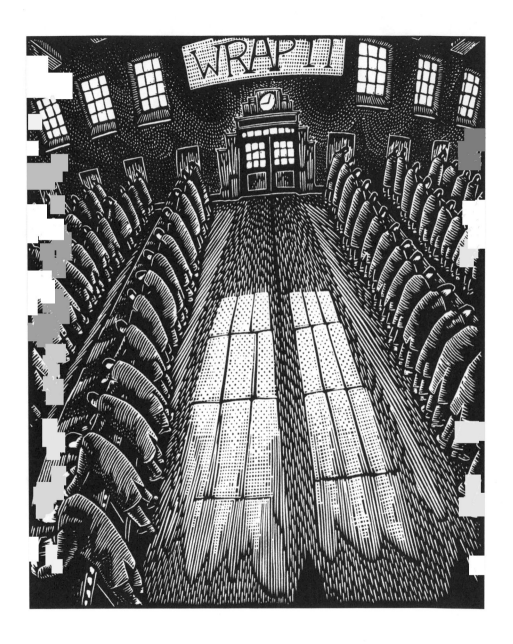

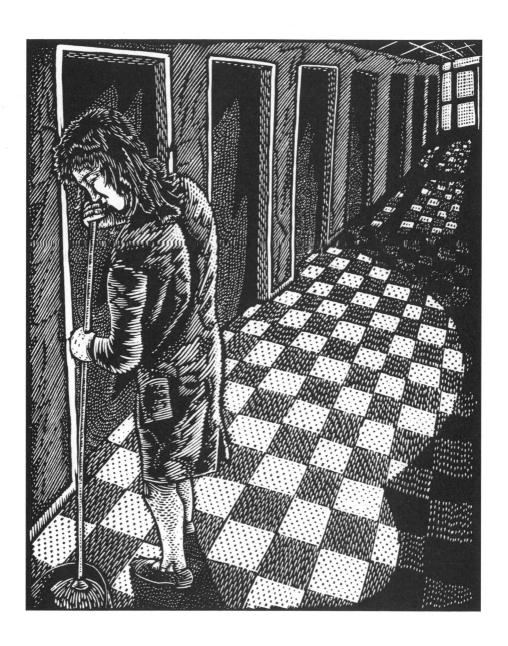

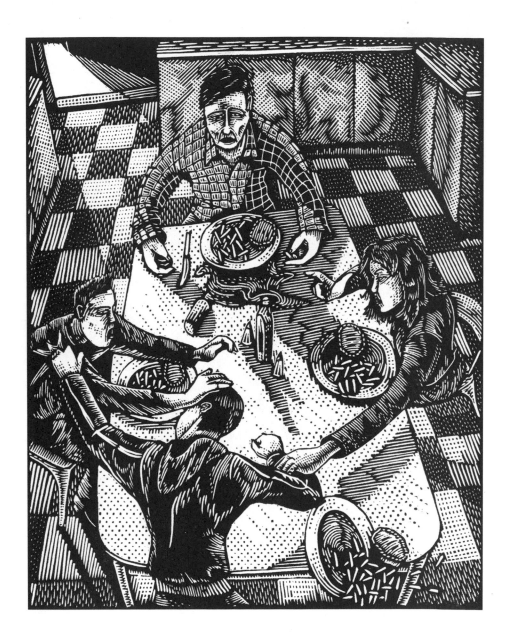

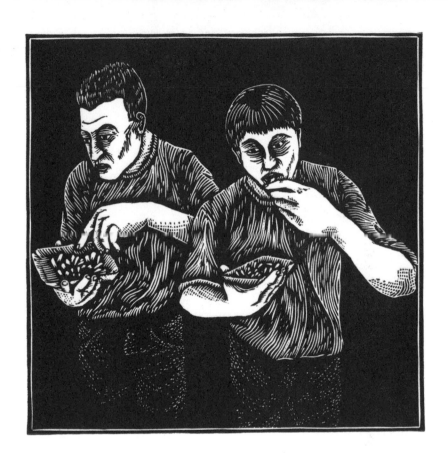

# CHAPTER
# FOUR

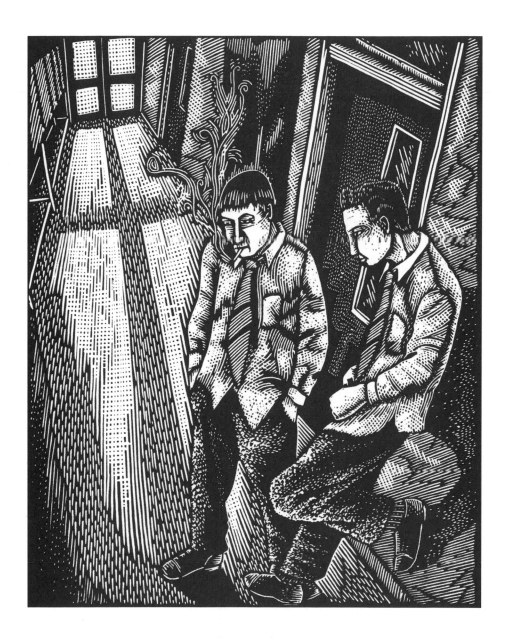

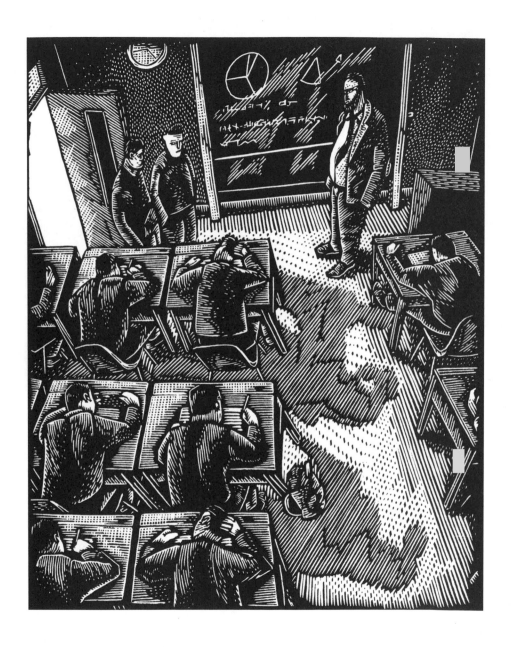

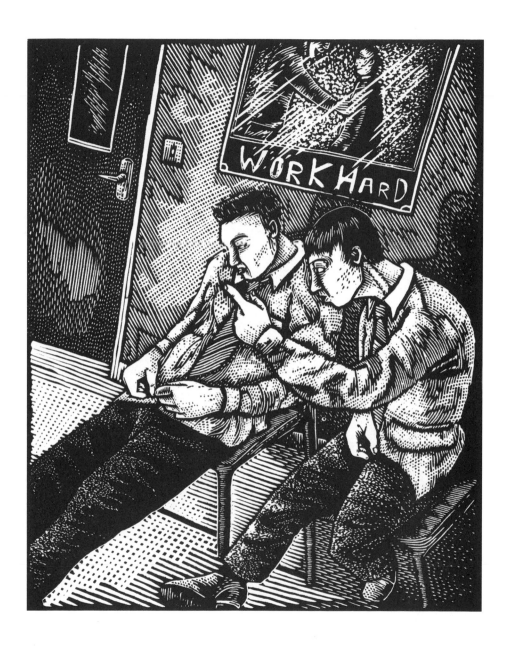

79

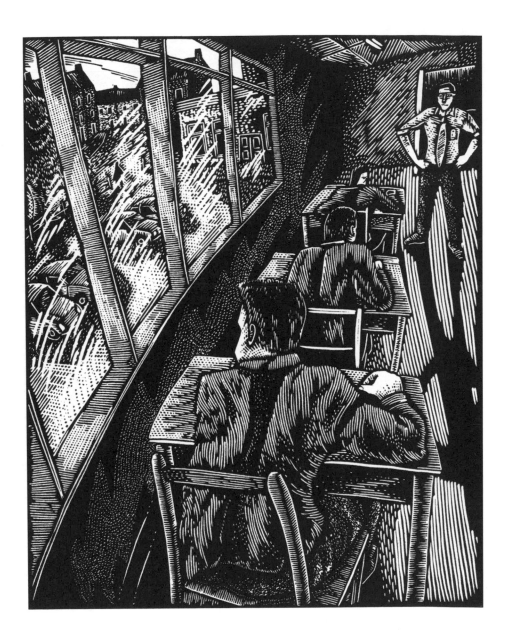

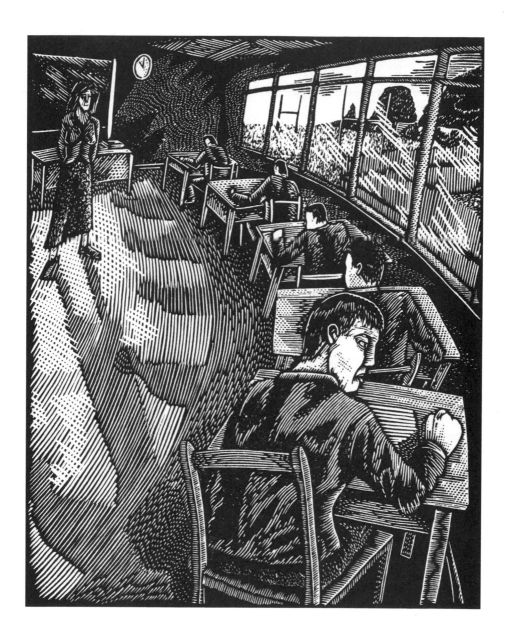

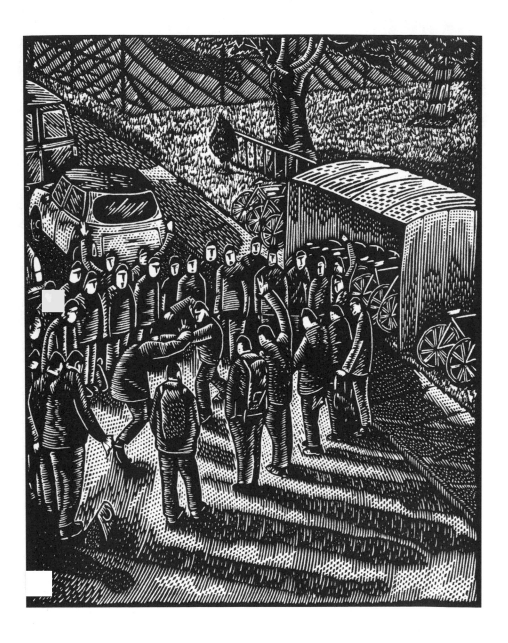

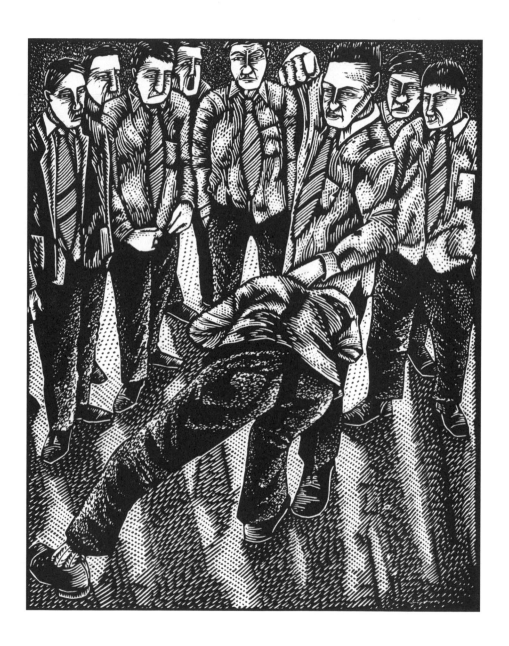

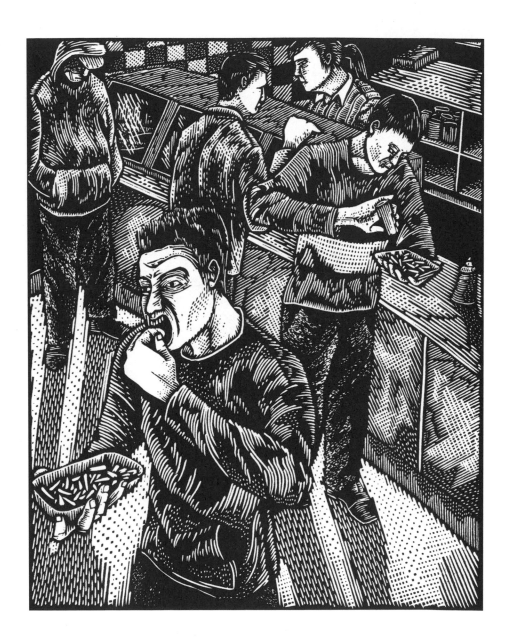

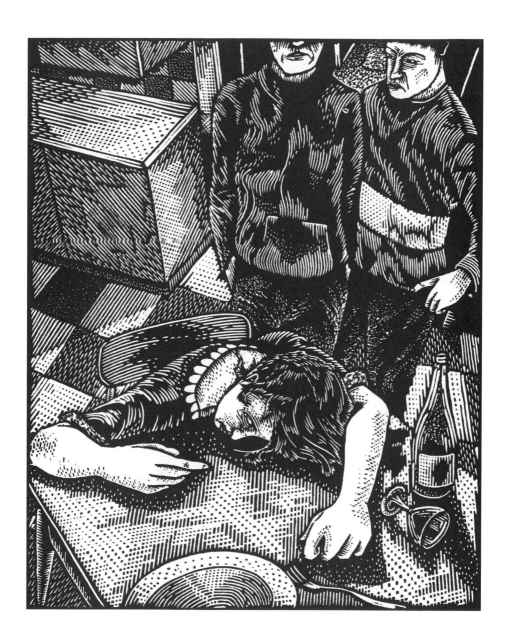

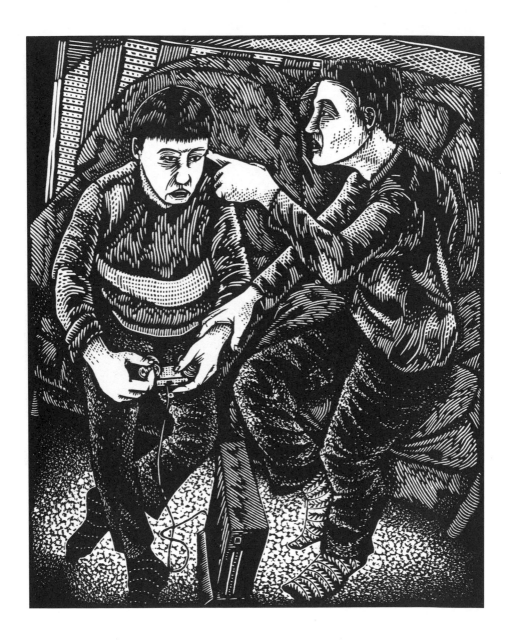

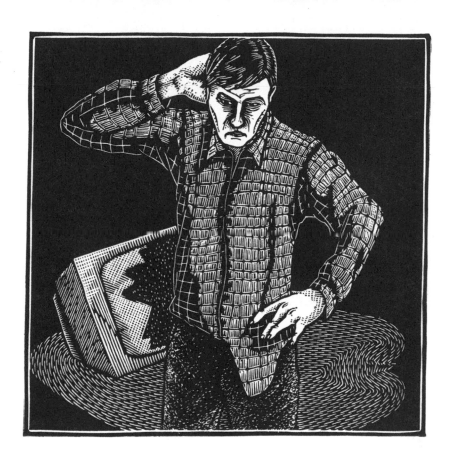

# CHAPTER FIVE

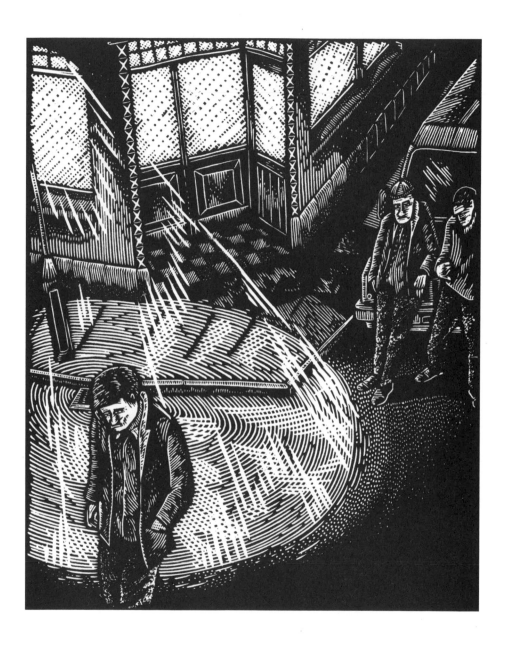

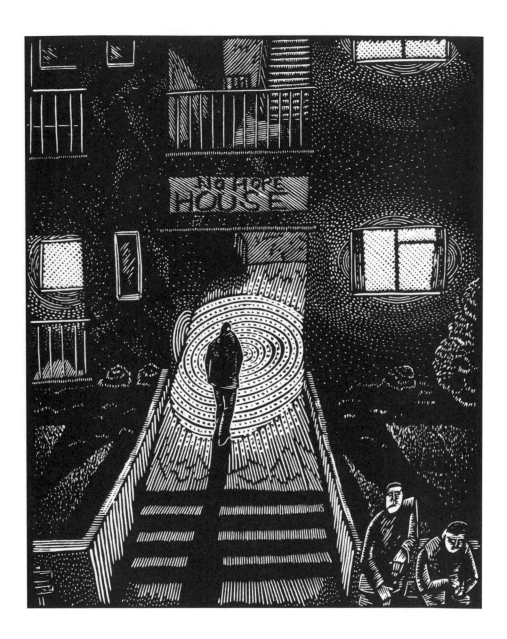

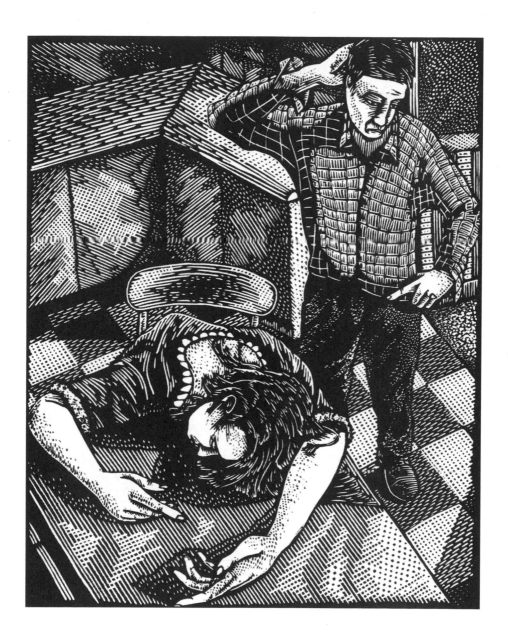

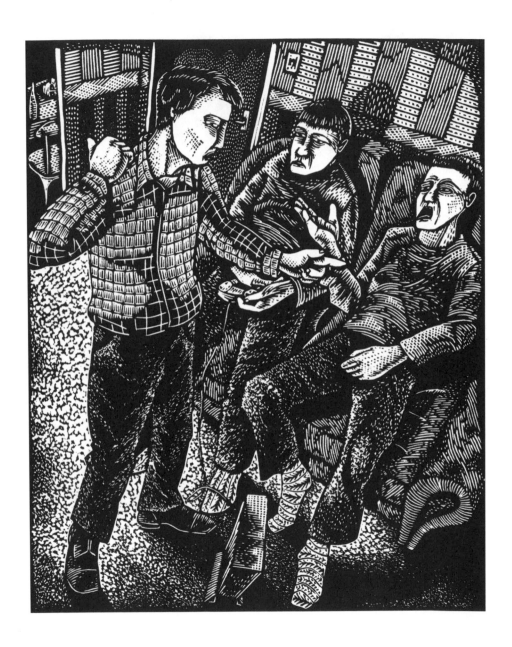

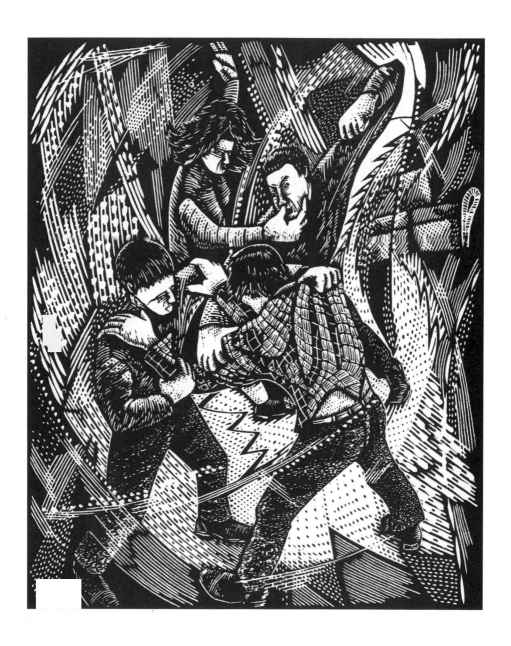

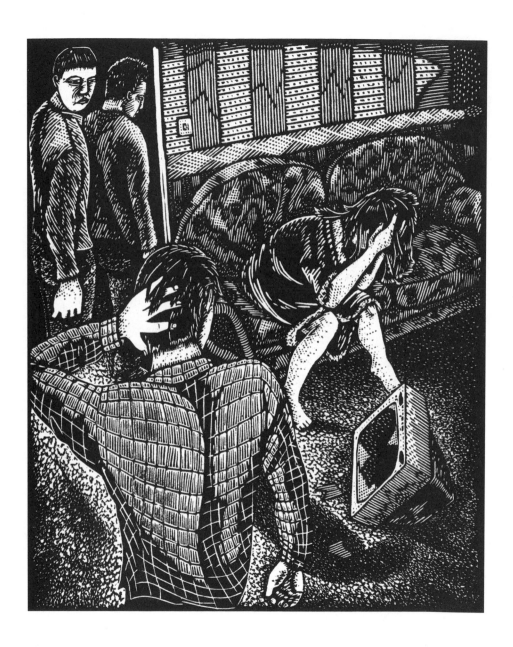

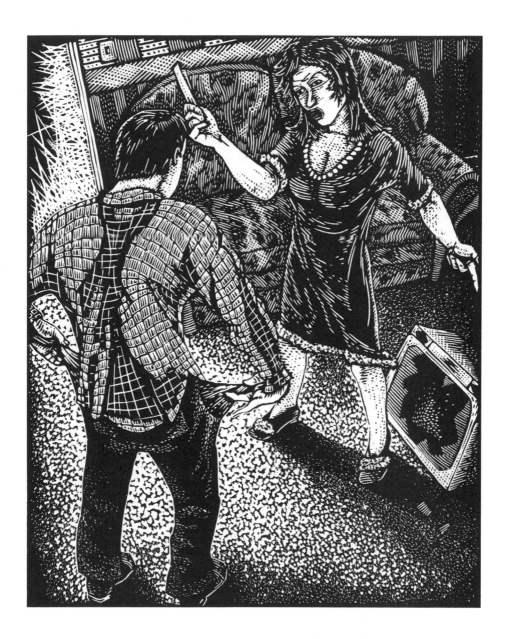

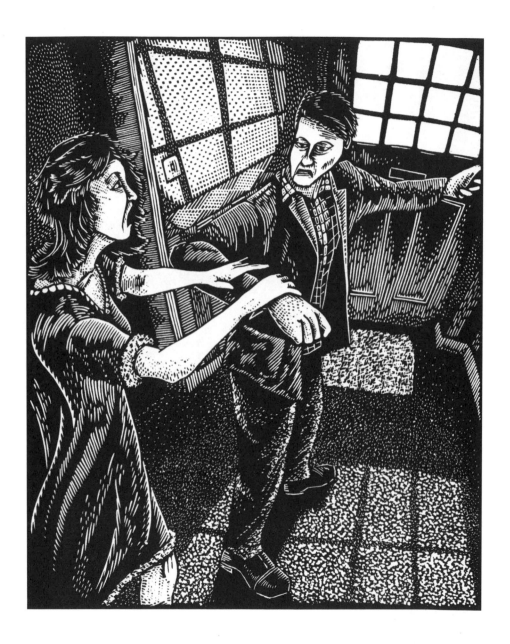

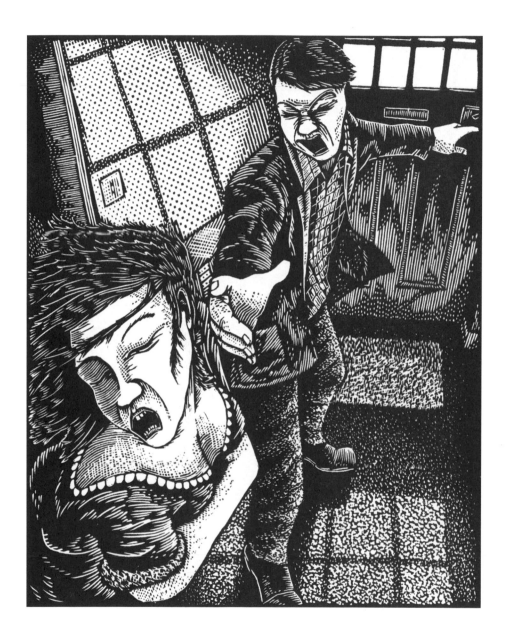

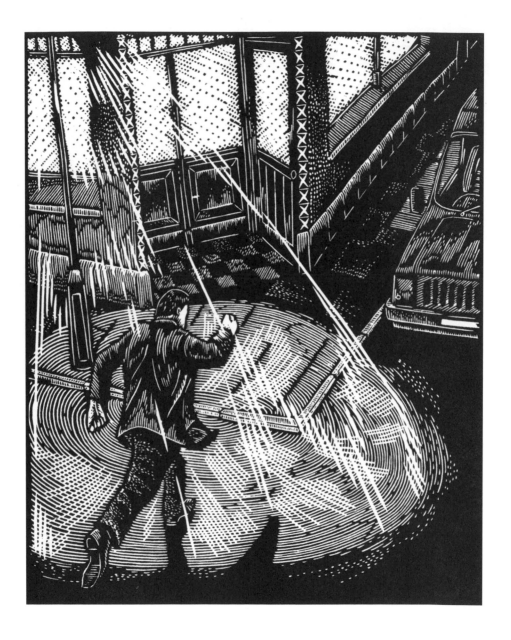

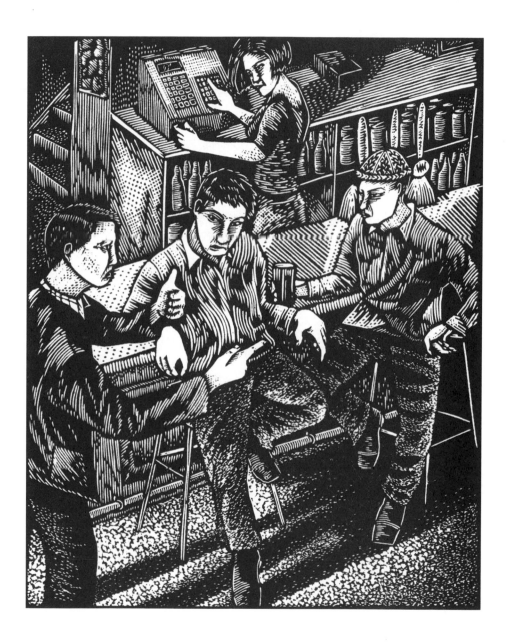

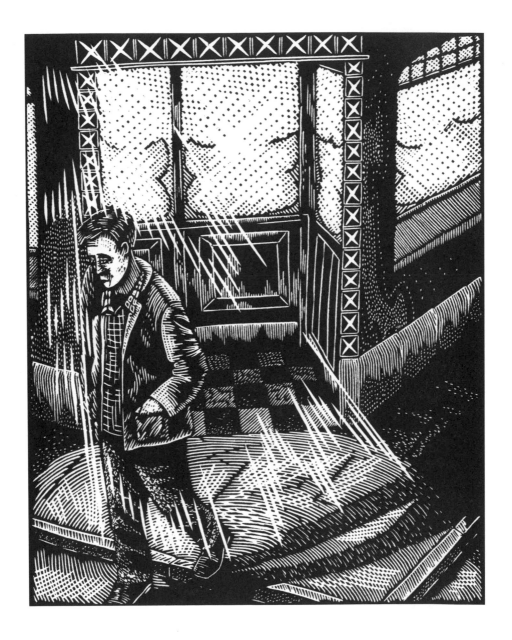

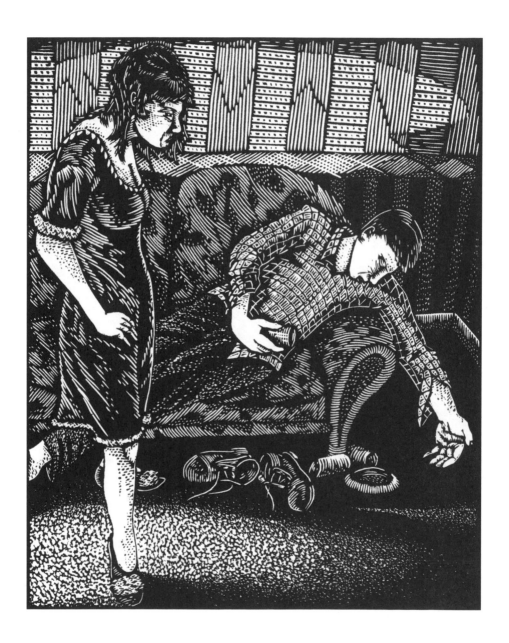

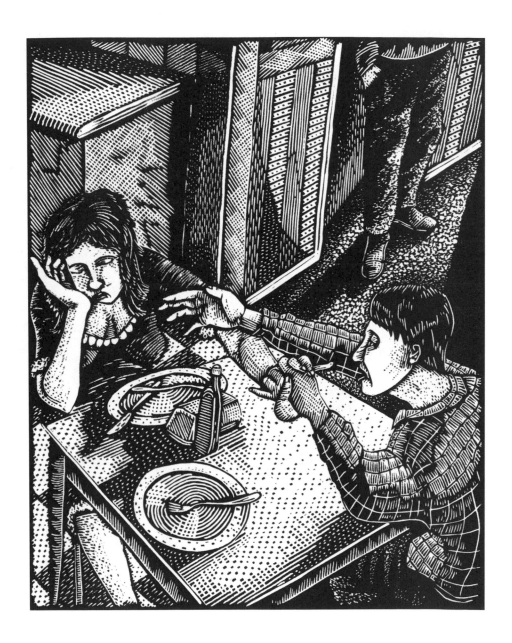

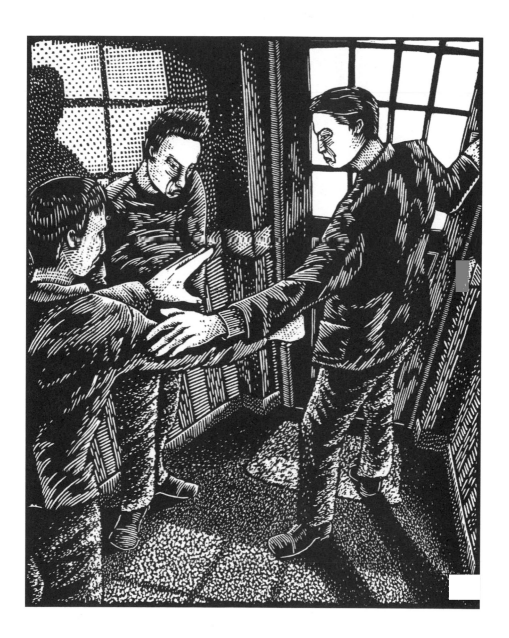

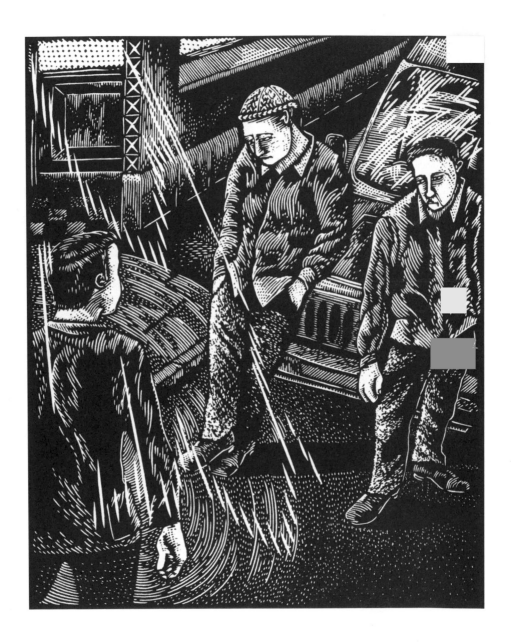

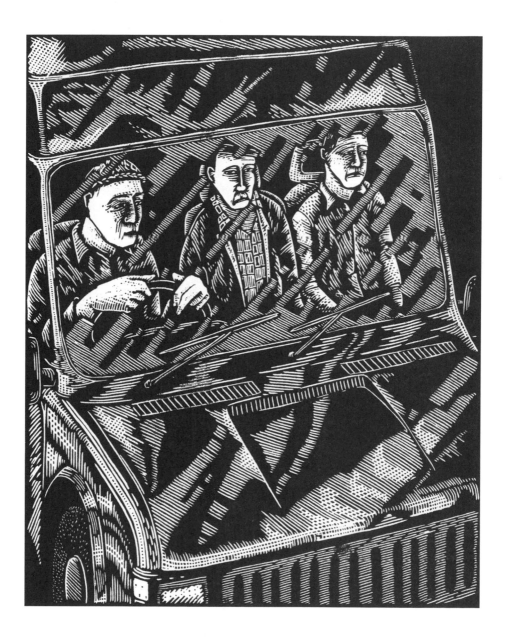

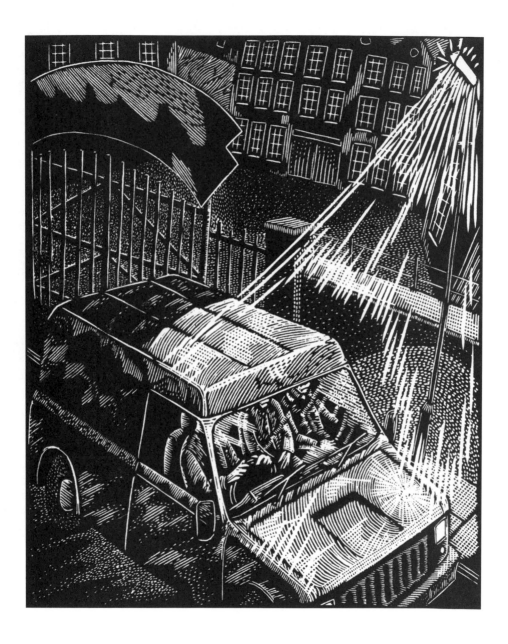

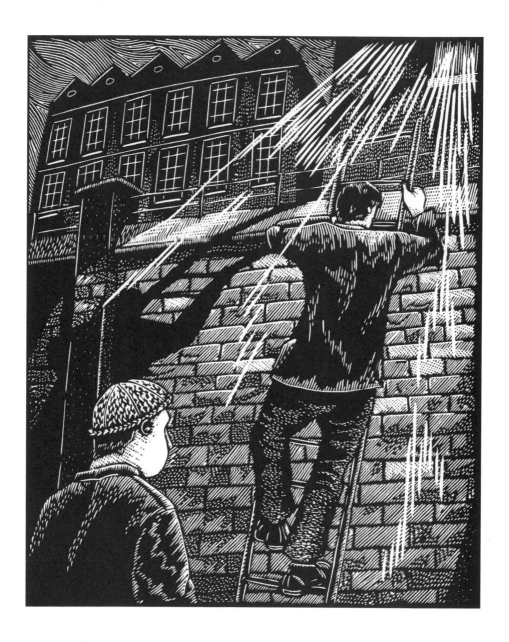

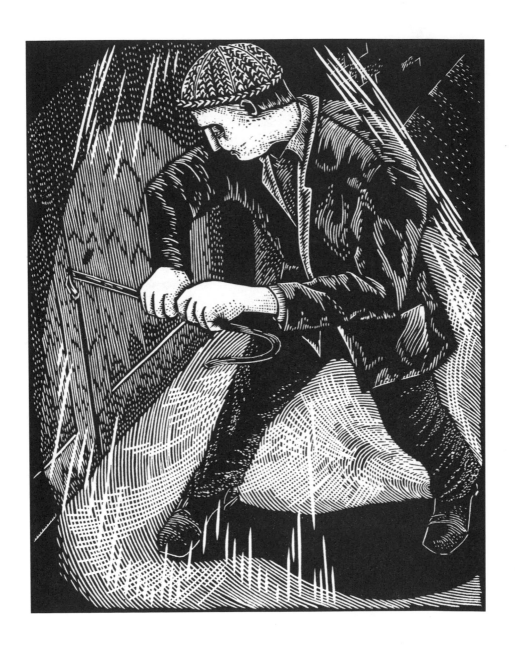

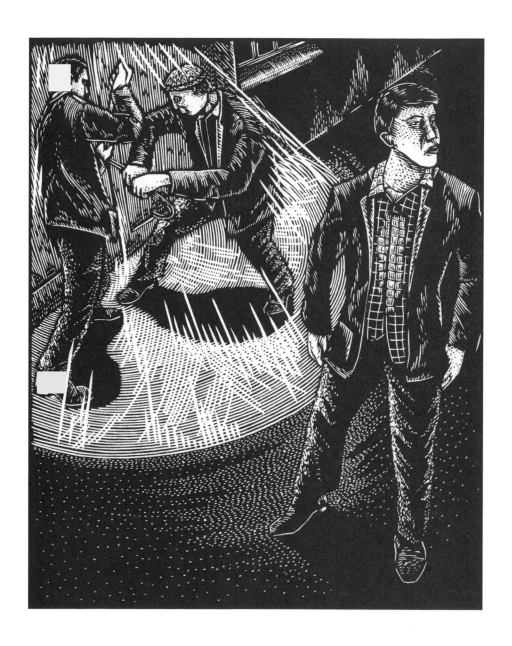

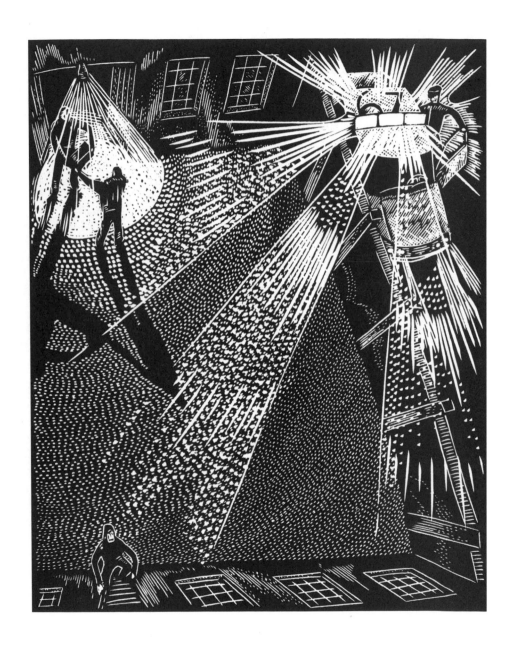

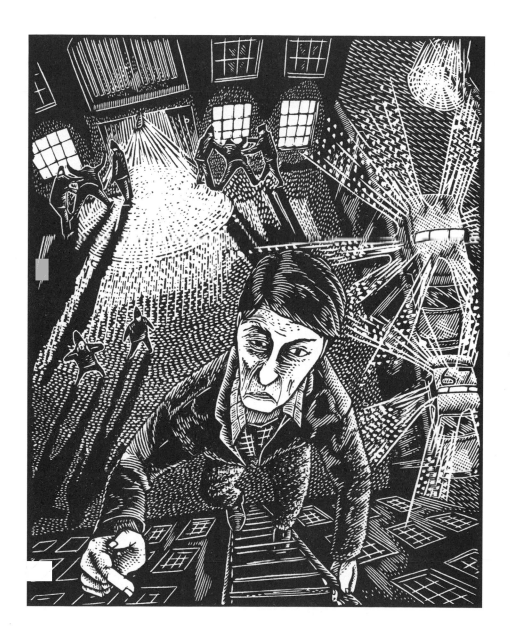

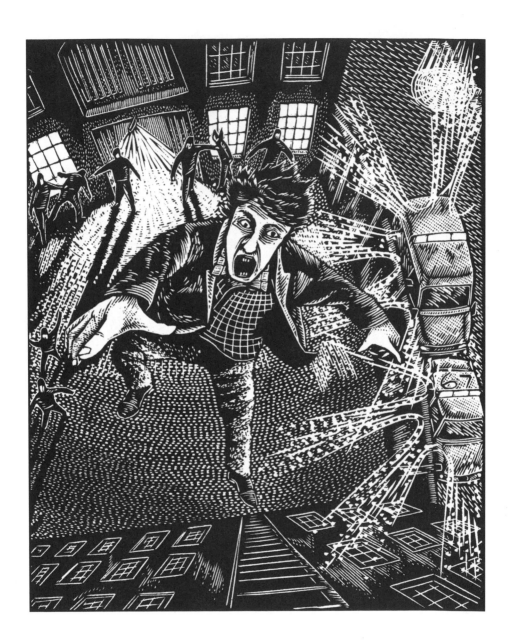

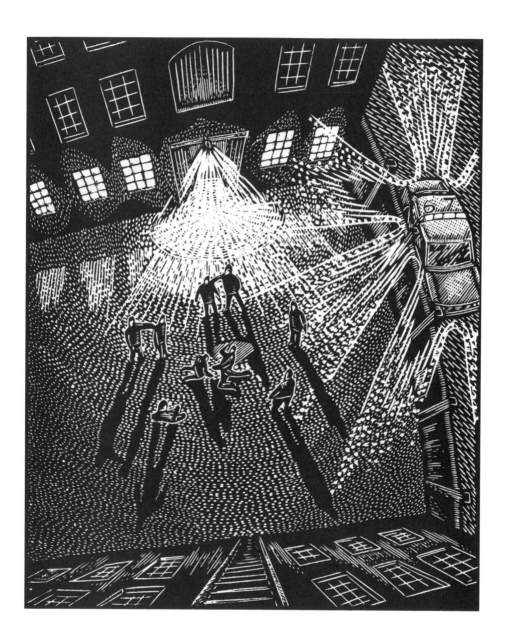

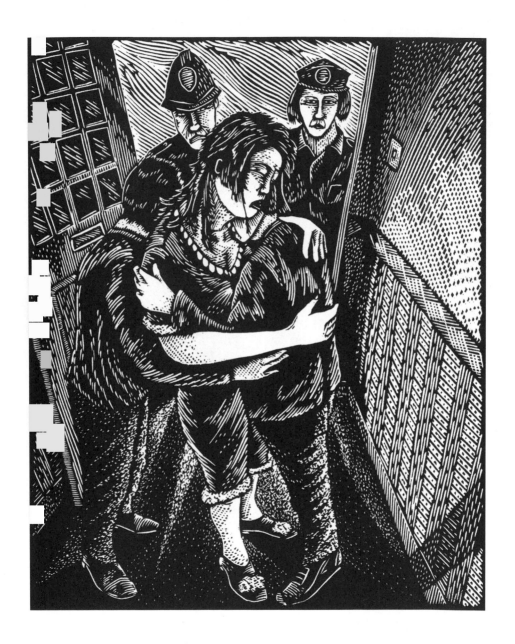

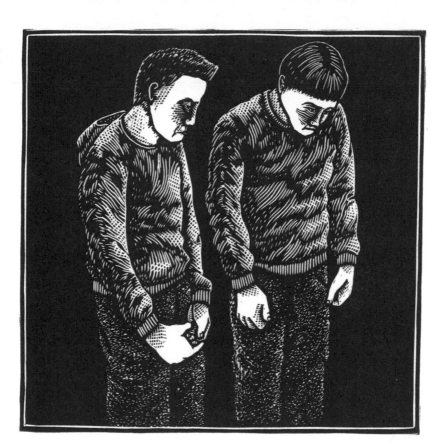

# CHAPTER
# SIX

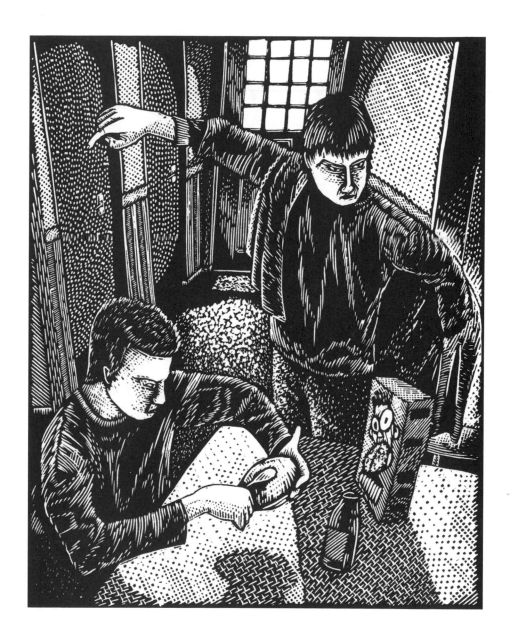

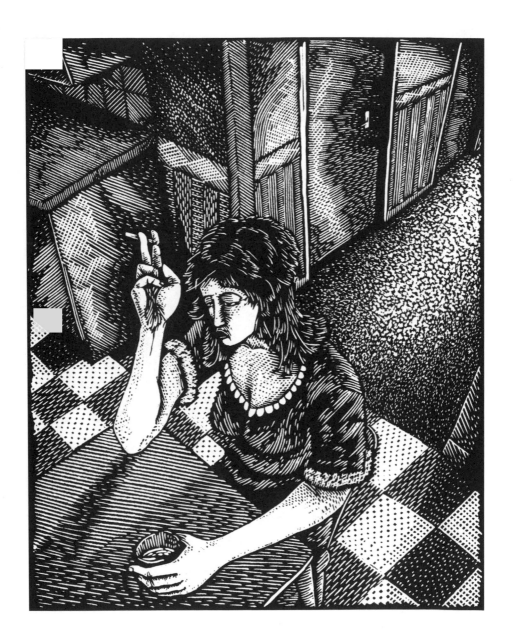

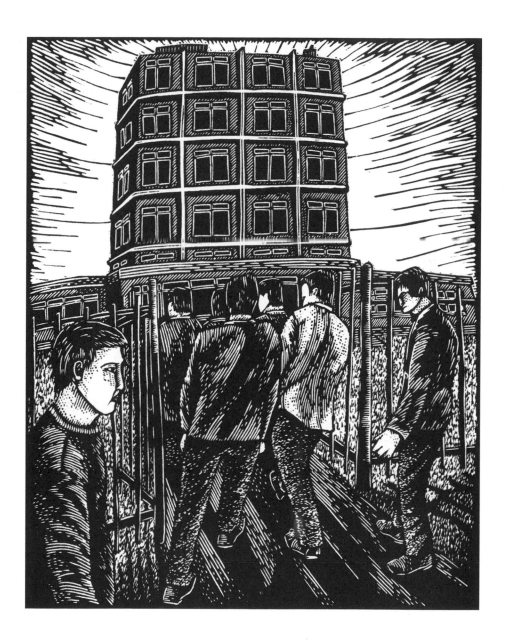

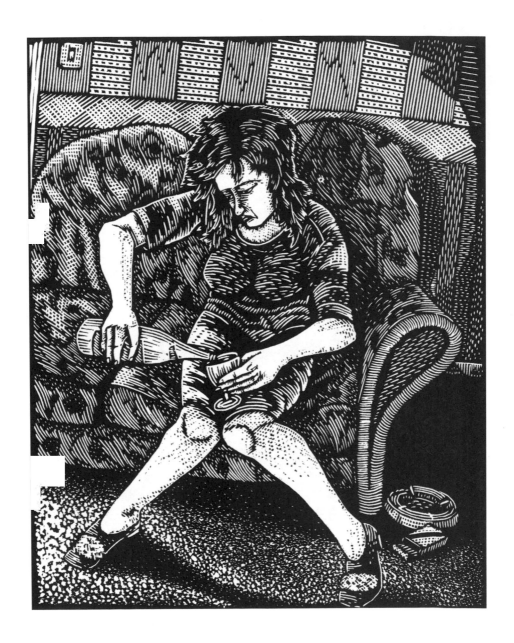

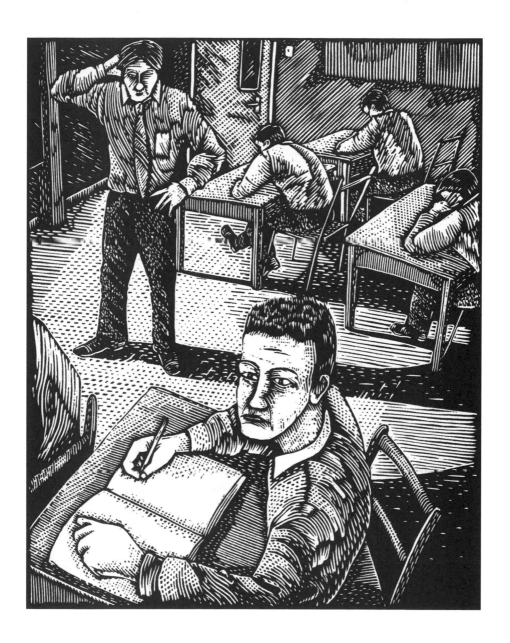

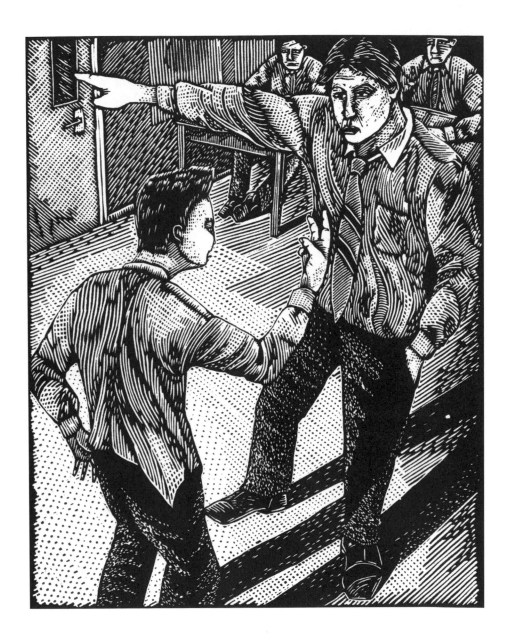

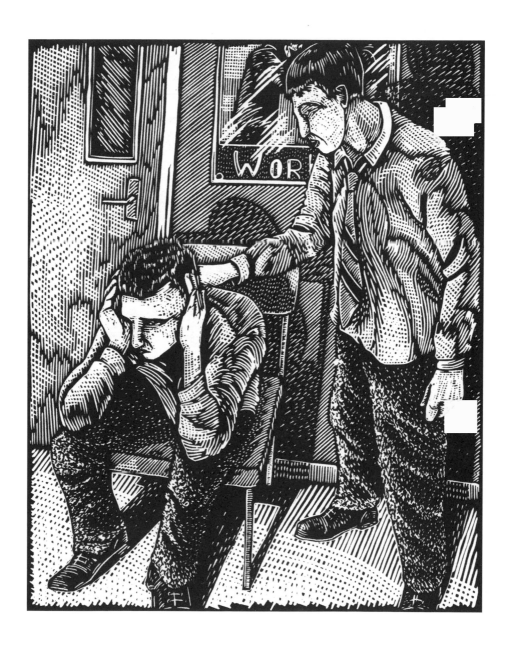

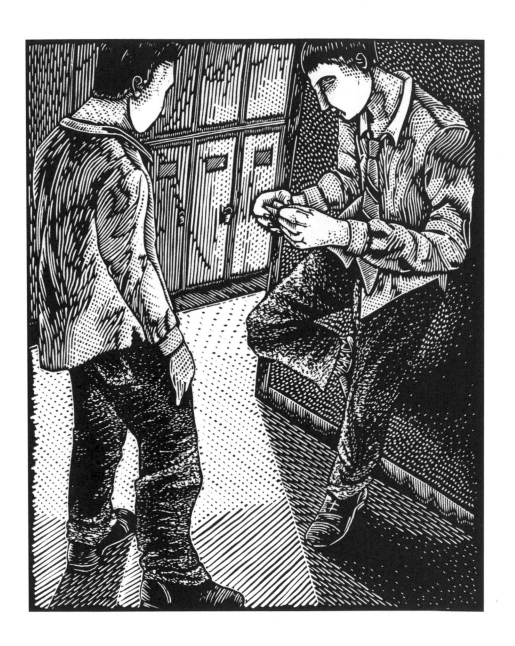

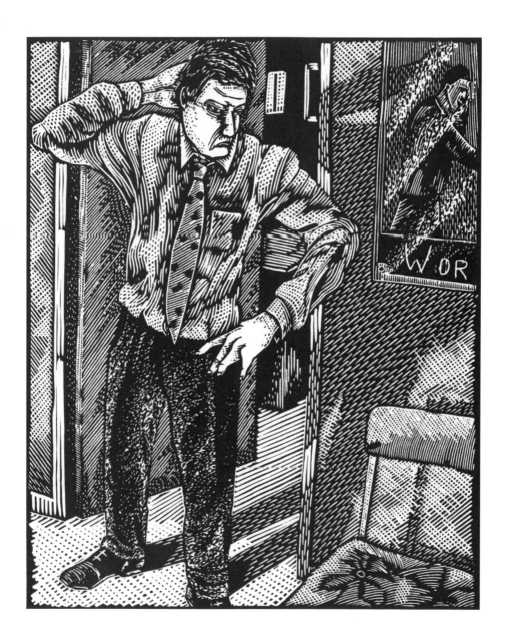

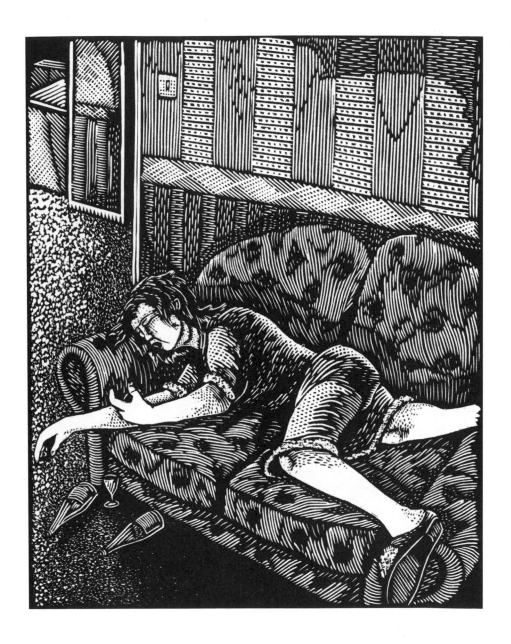

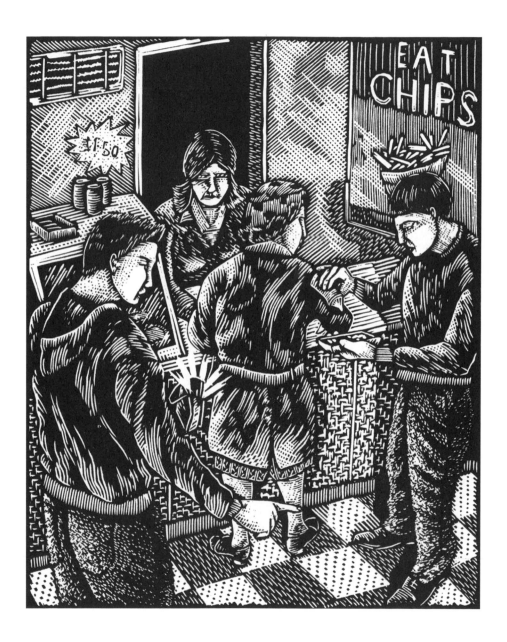

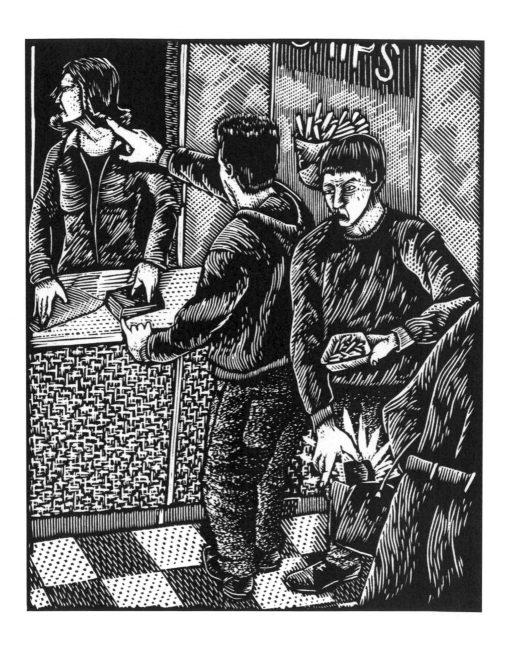

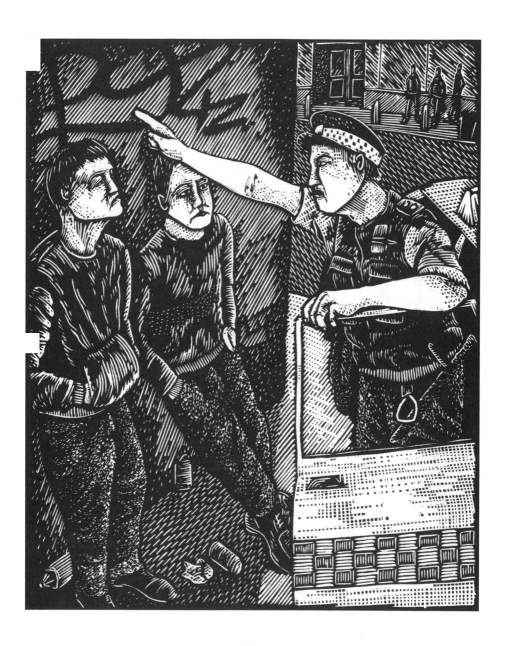

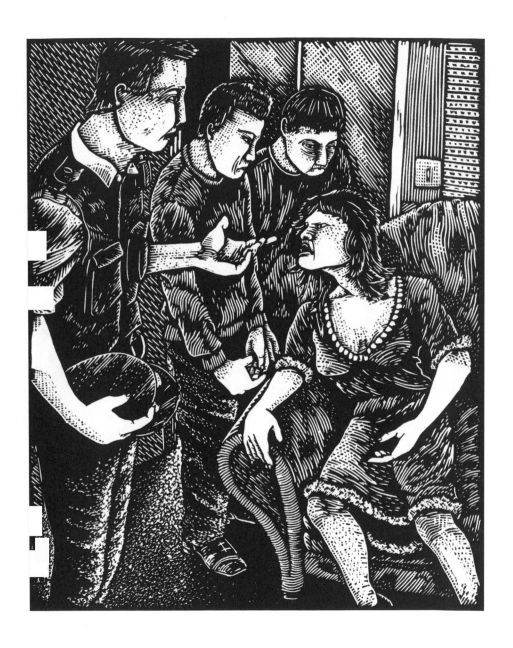

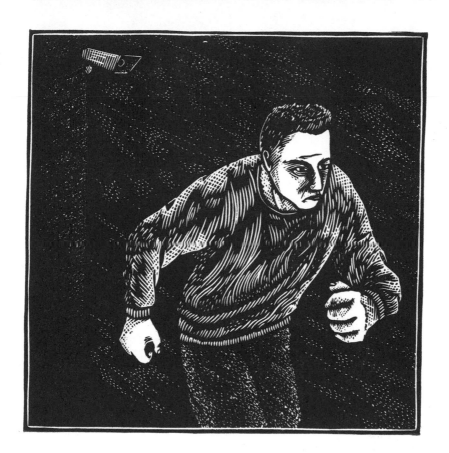

# CHAPTER
# SEVEN

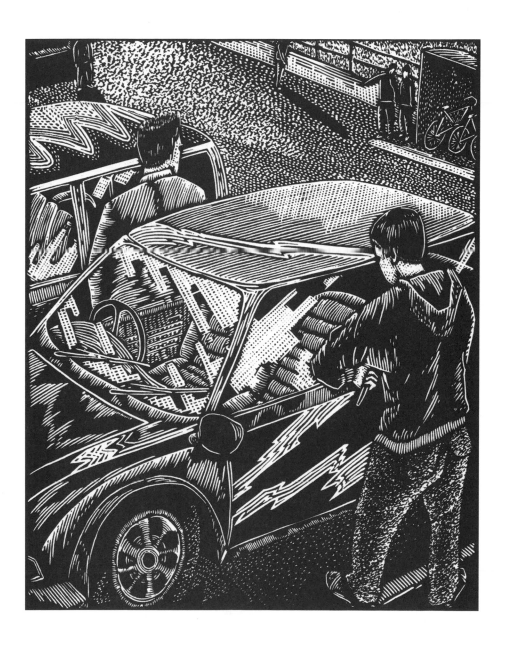

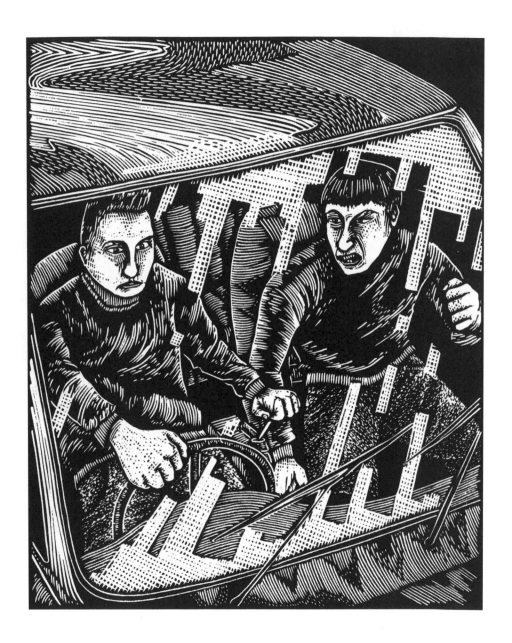

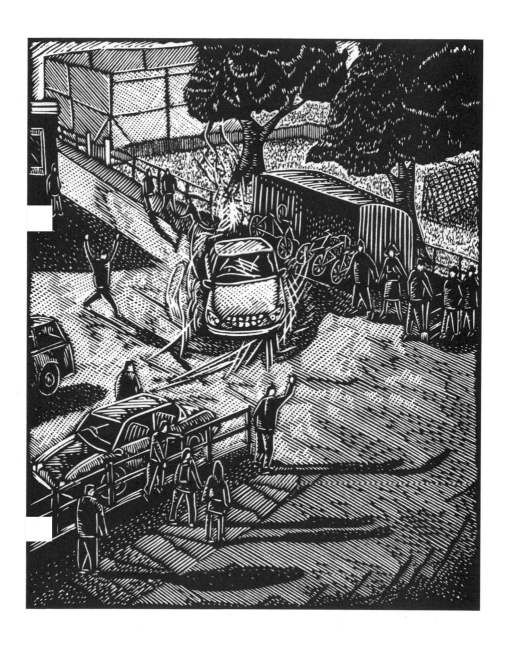

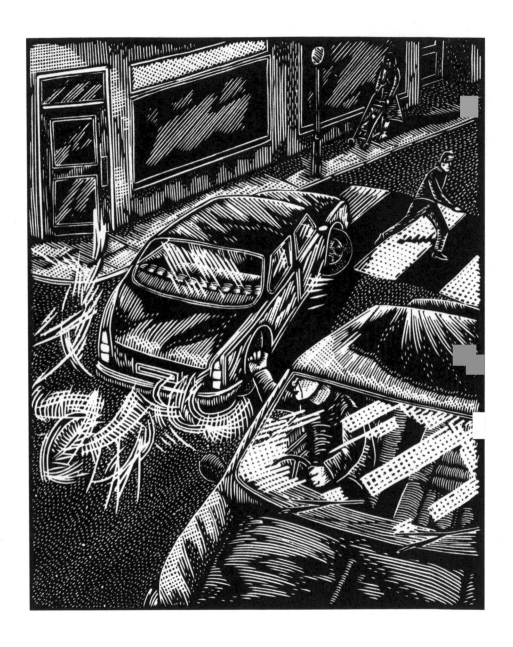

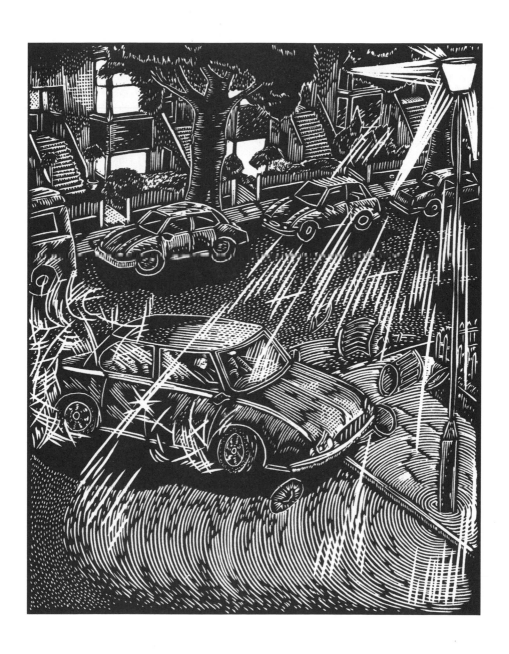

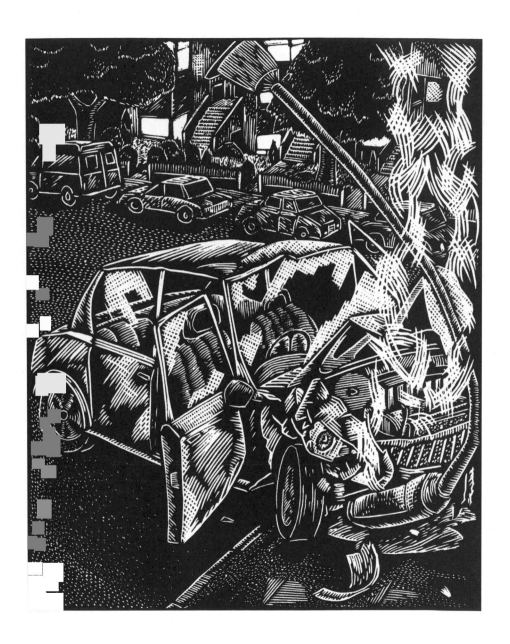

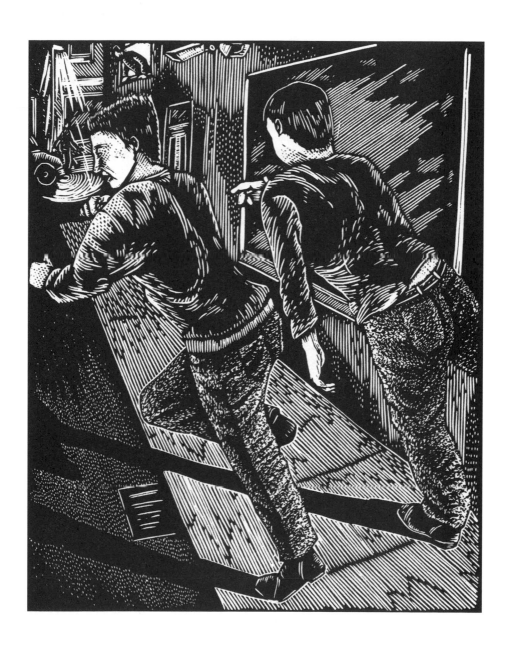

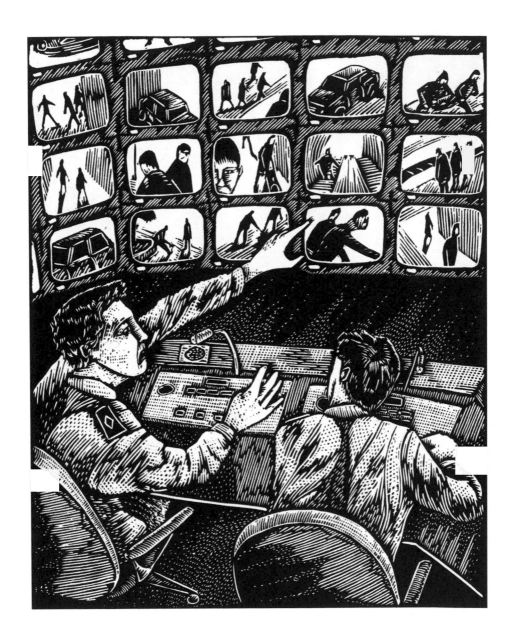

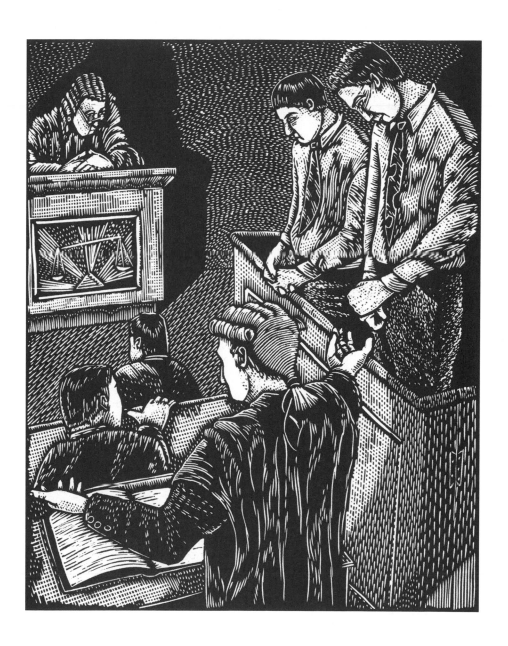

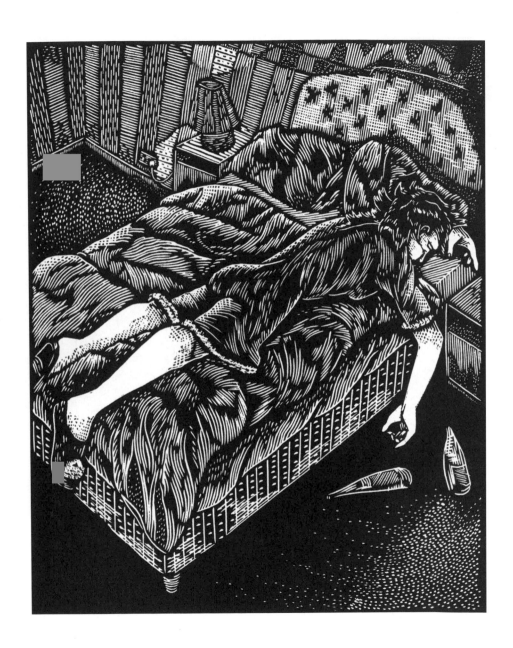

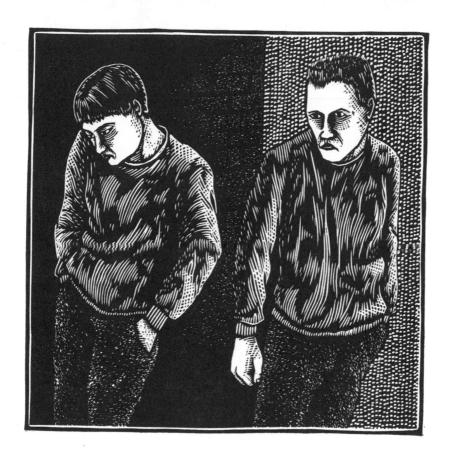

# CHAPTER
# EIGHT

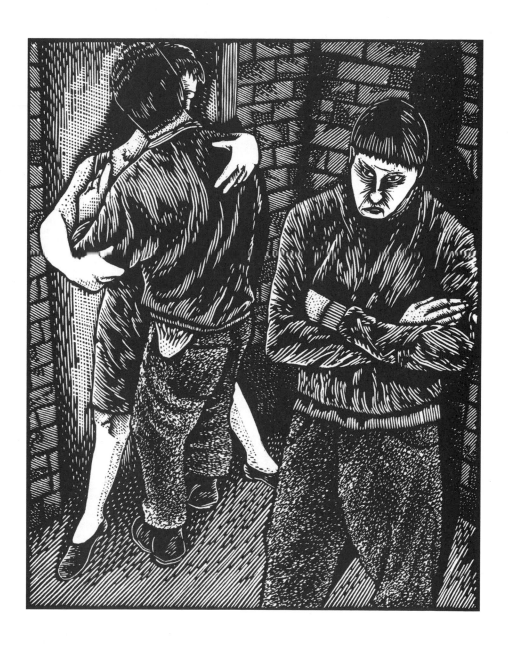

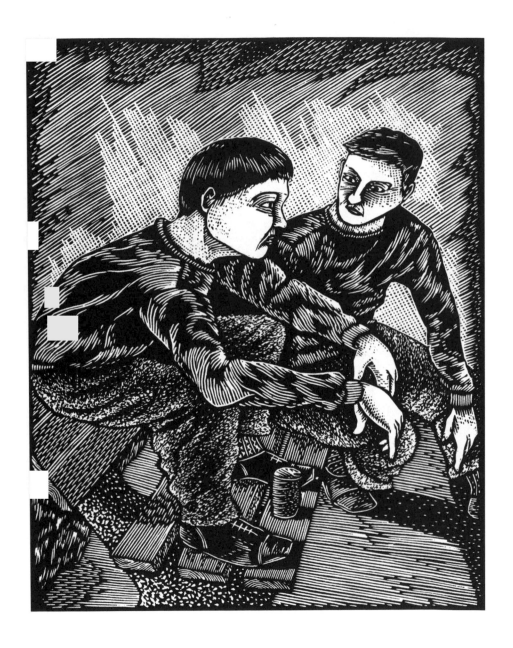

146

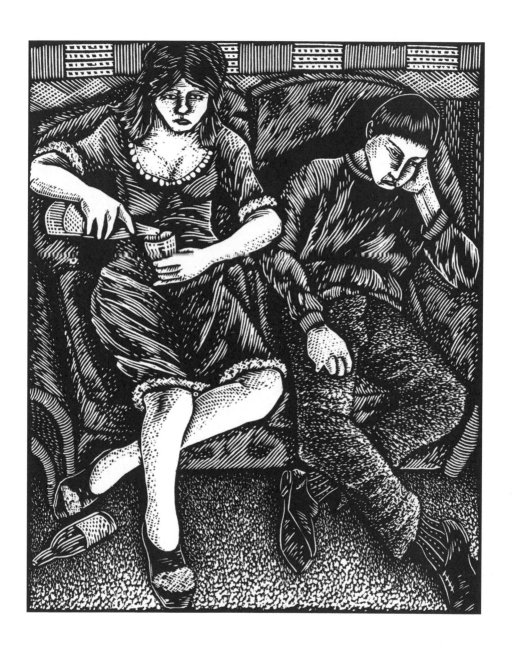

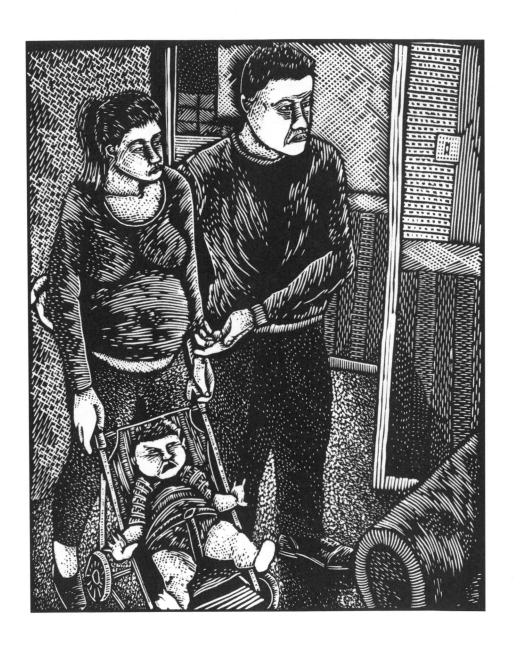

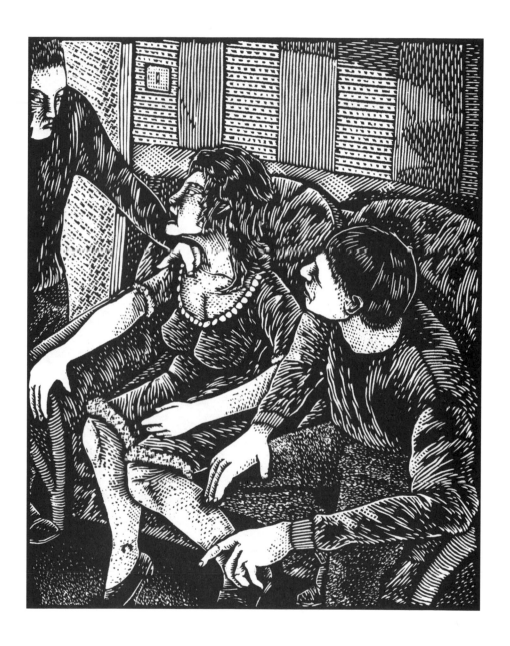

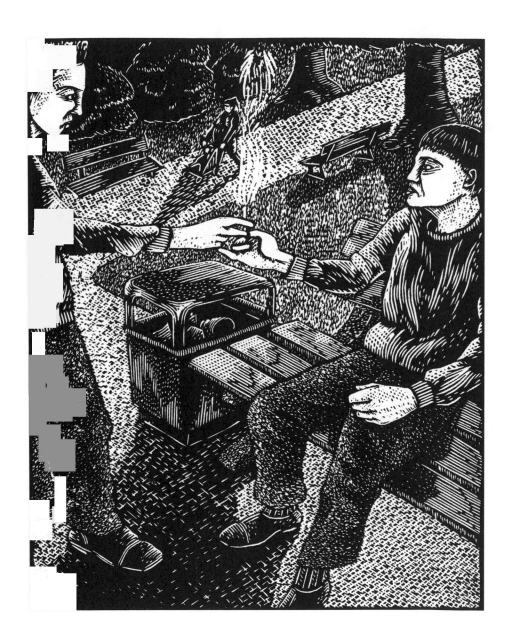

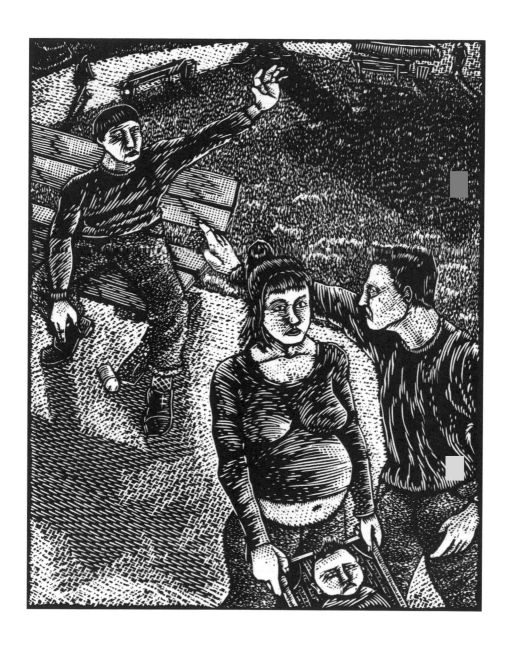

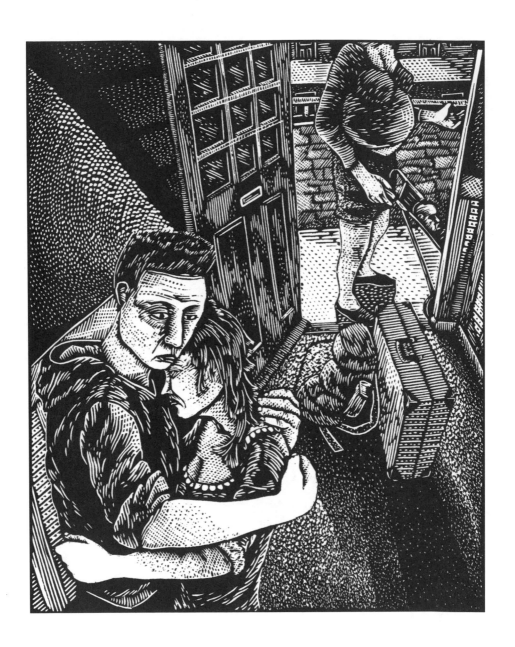

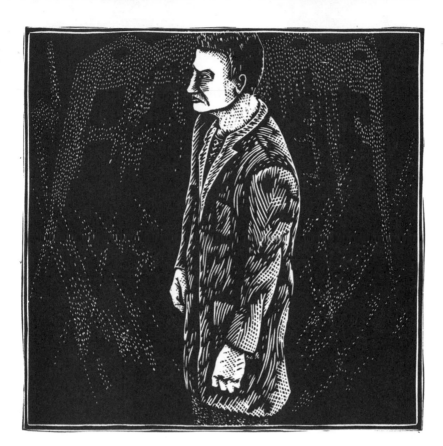

# CHAPTER
# NINE

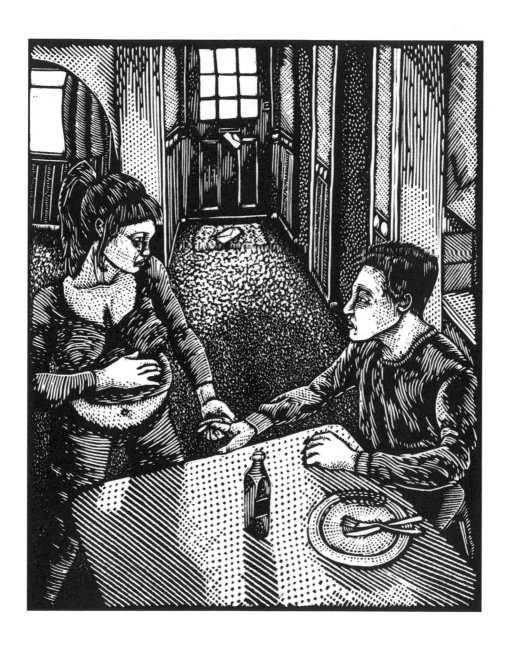

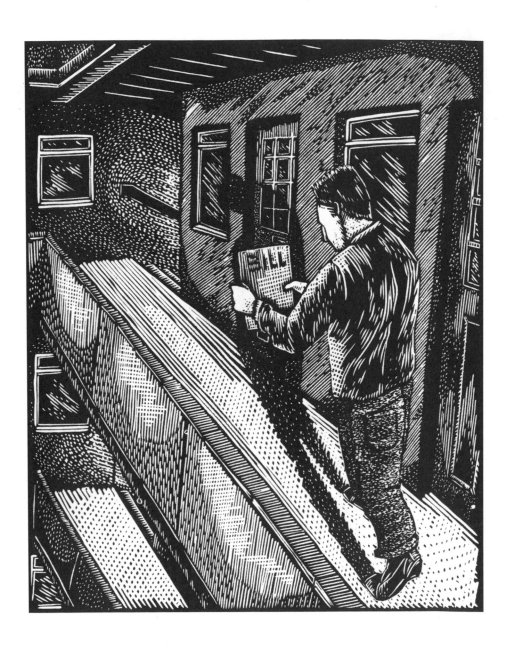

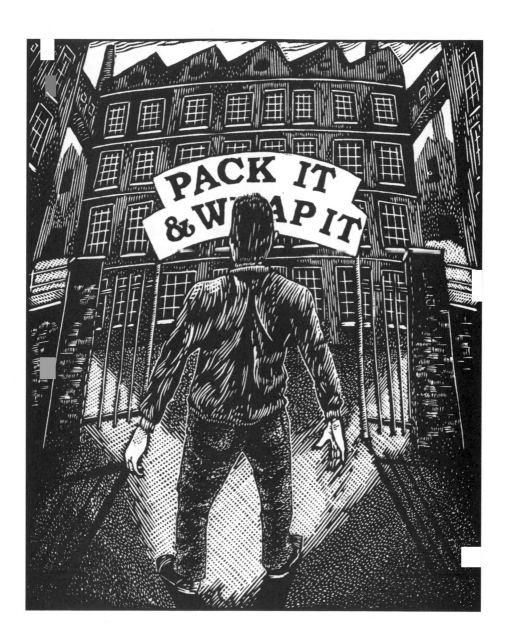

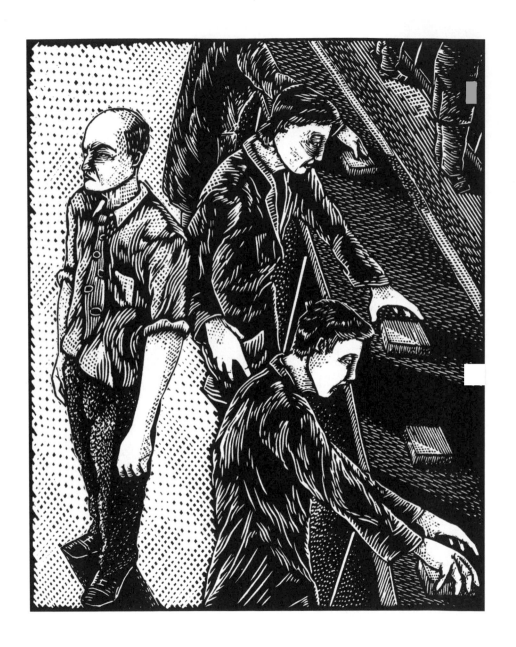

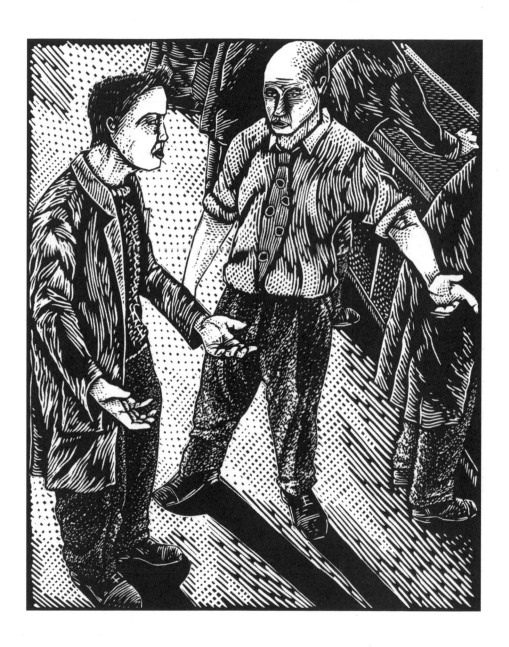

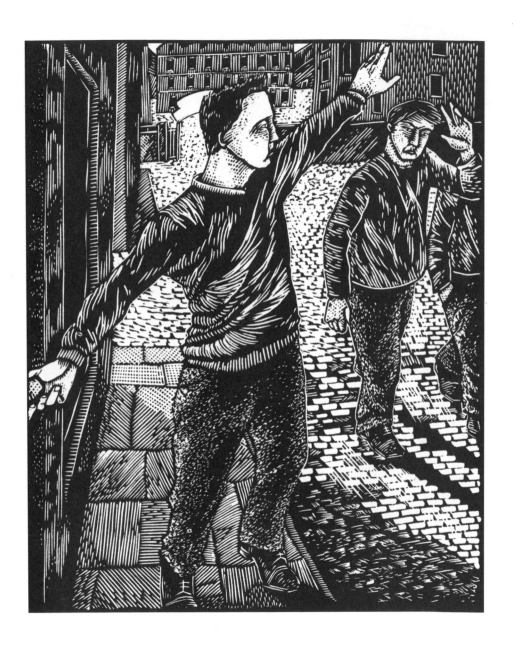

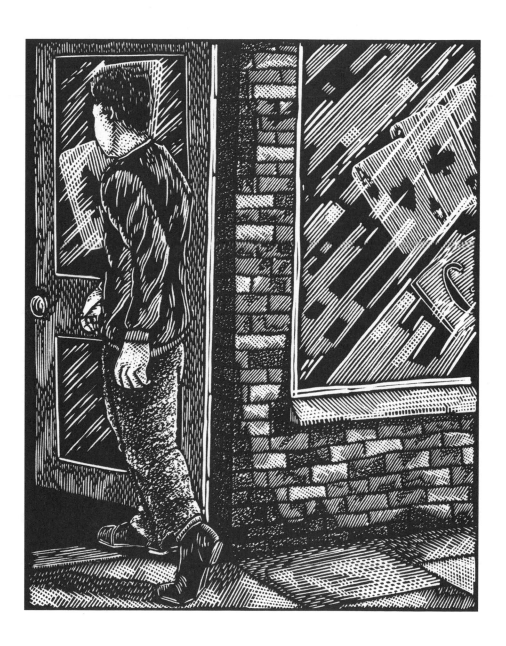

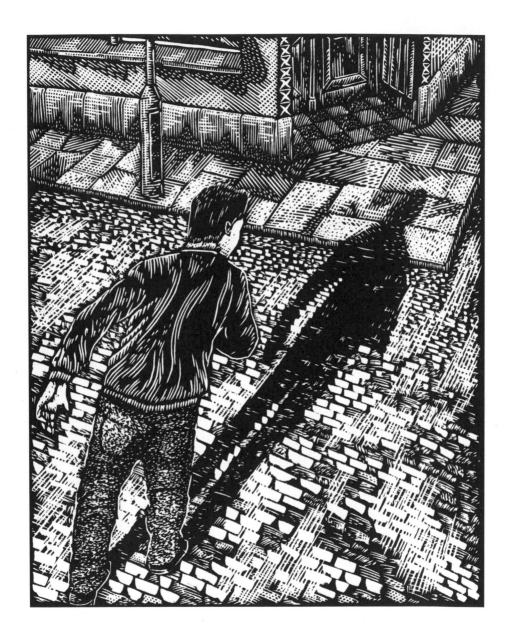

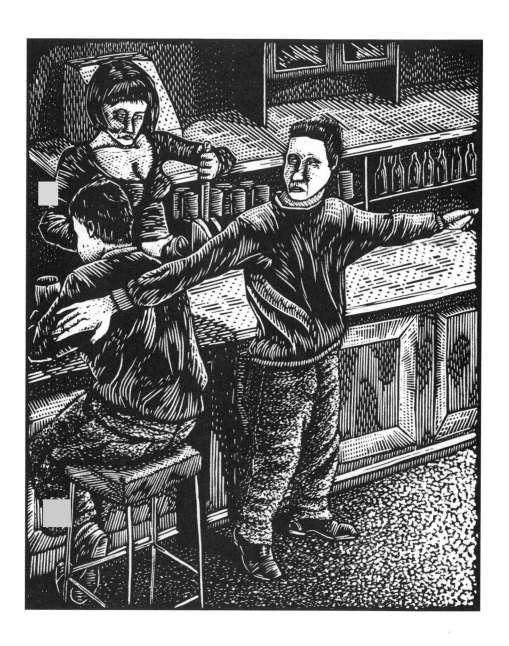

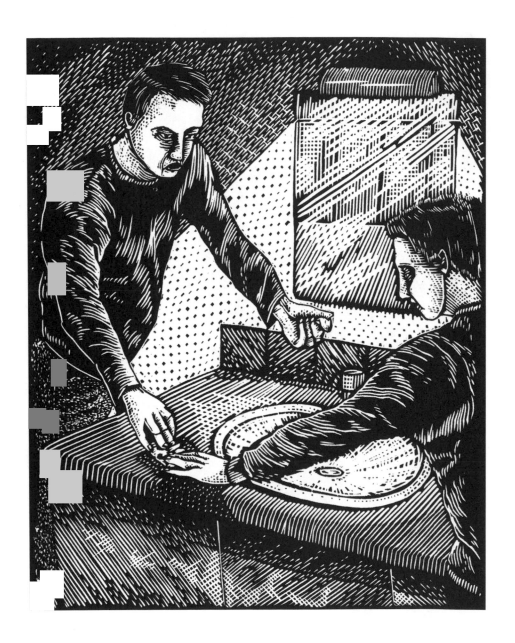

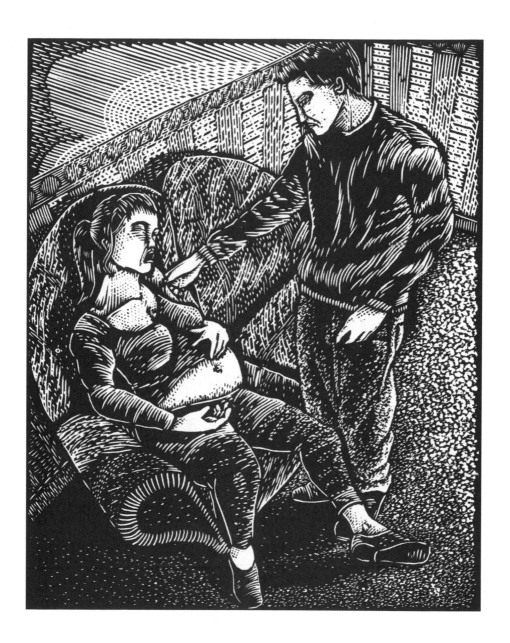

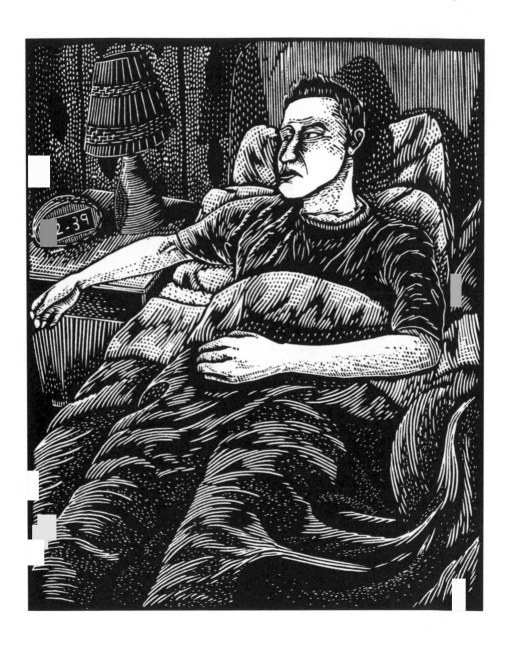

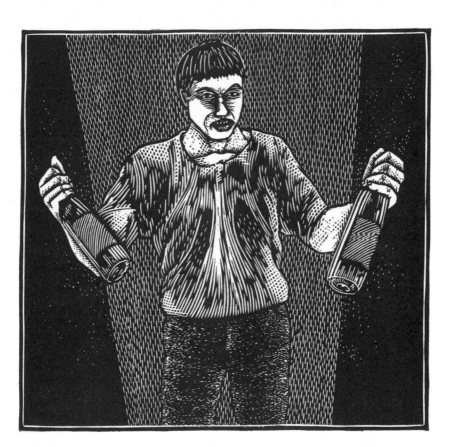

# CHAPTER
# TEN

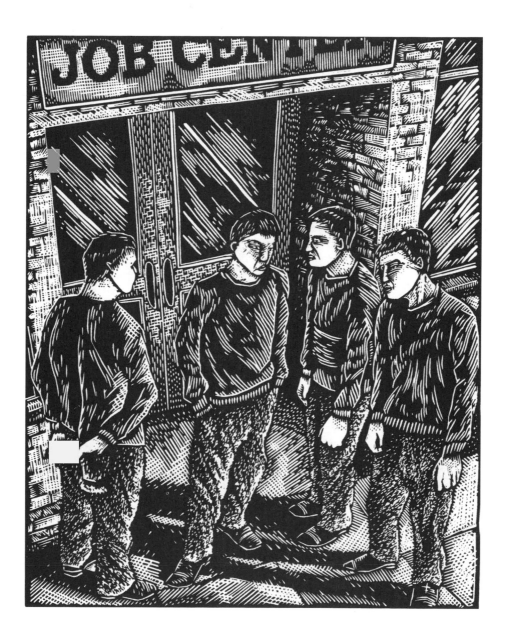

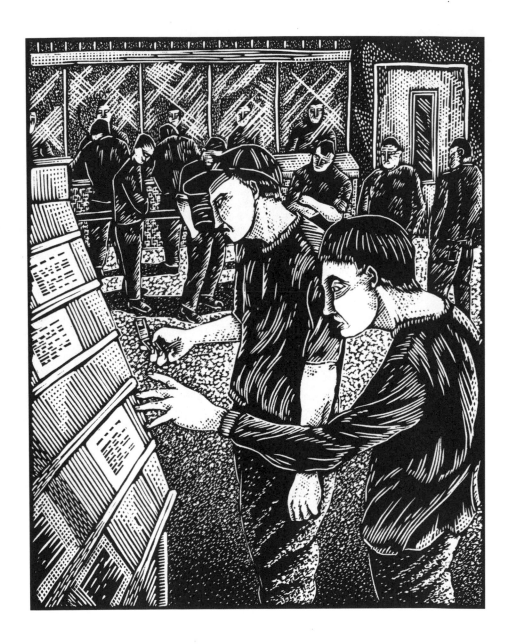

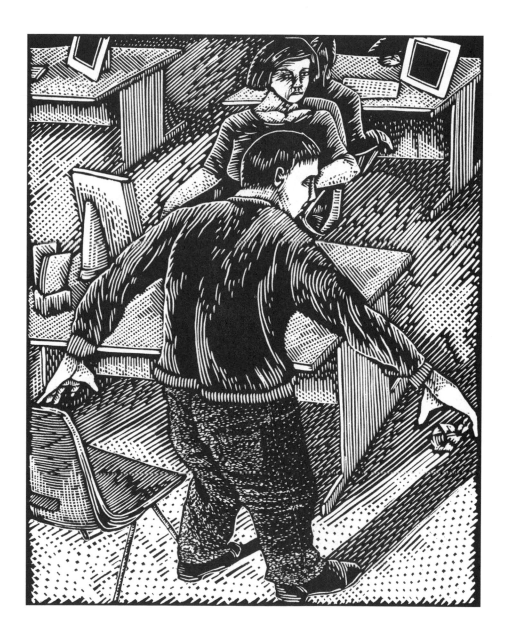

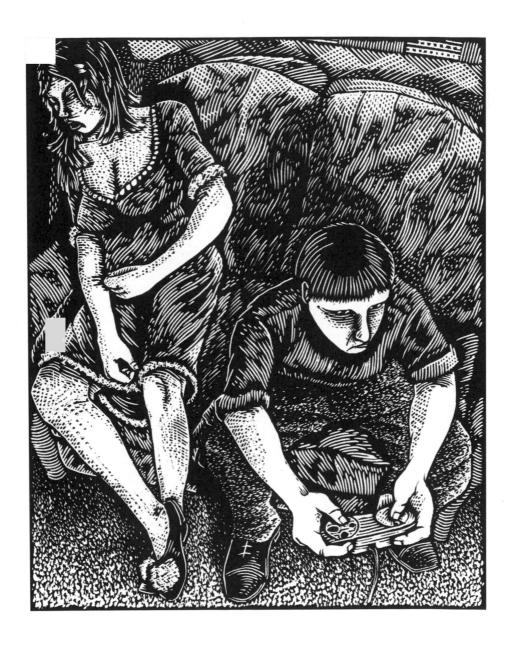

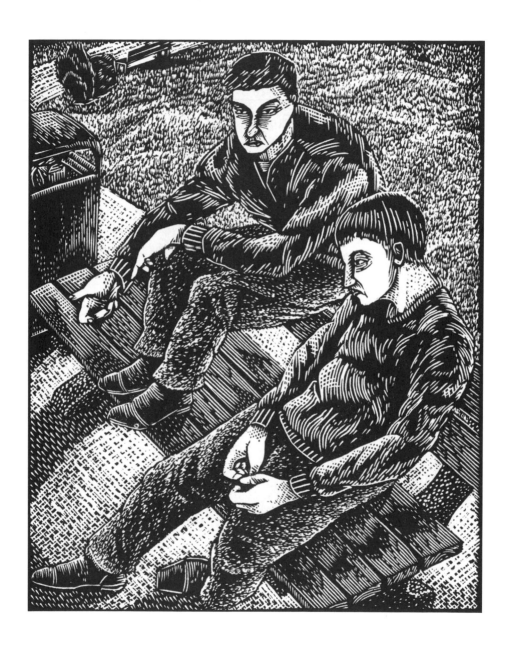

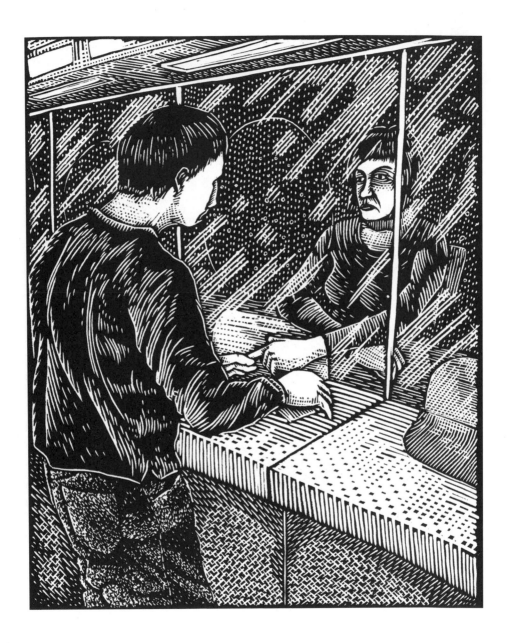

174

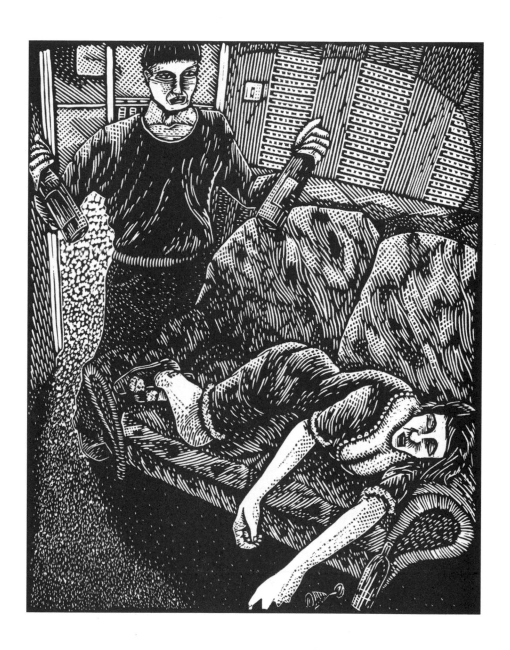

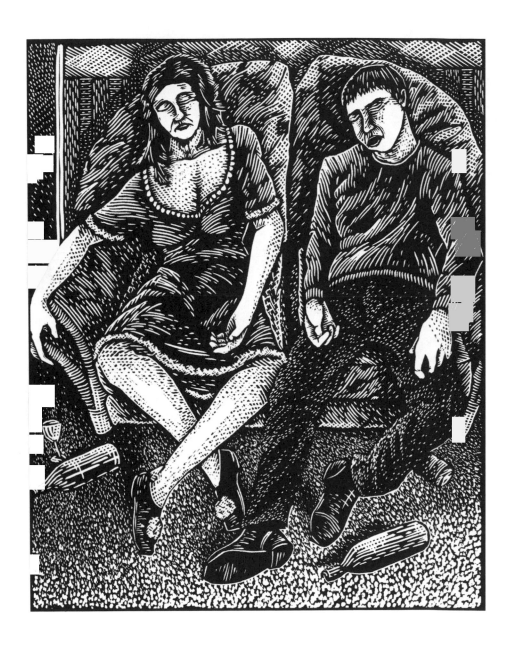

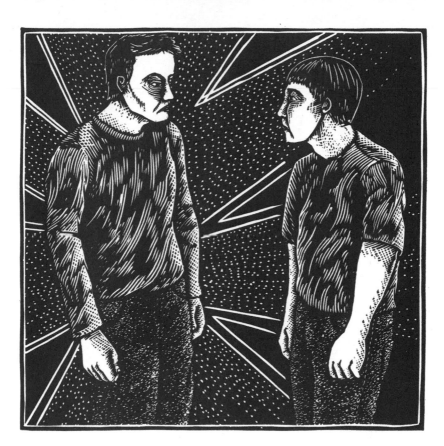

# CHAPTER
# ELEVEN

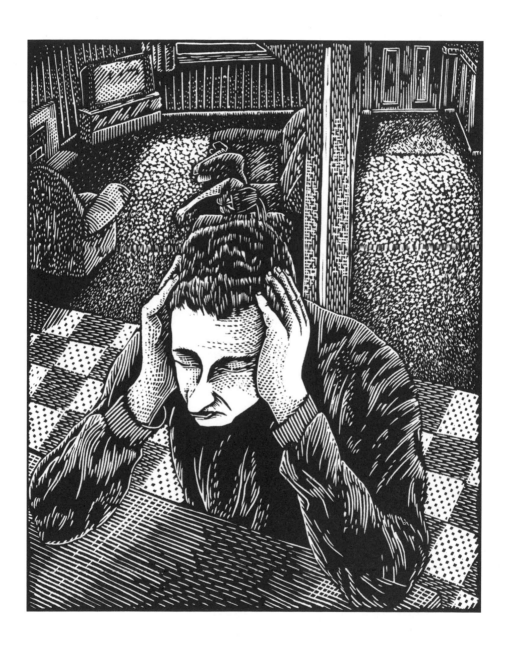

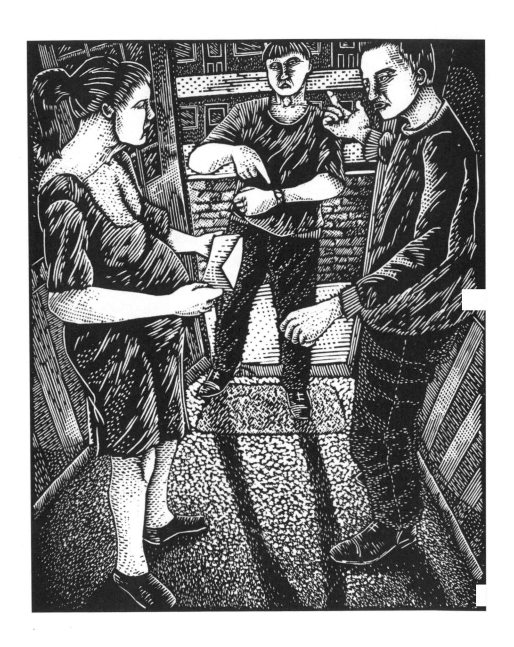

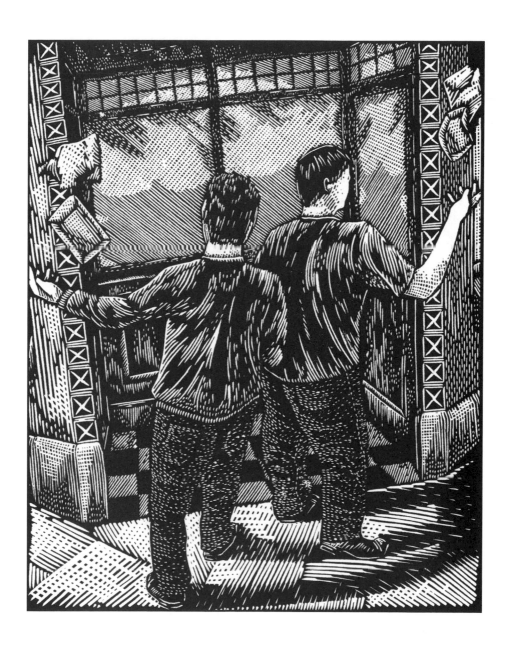

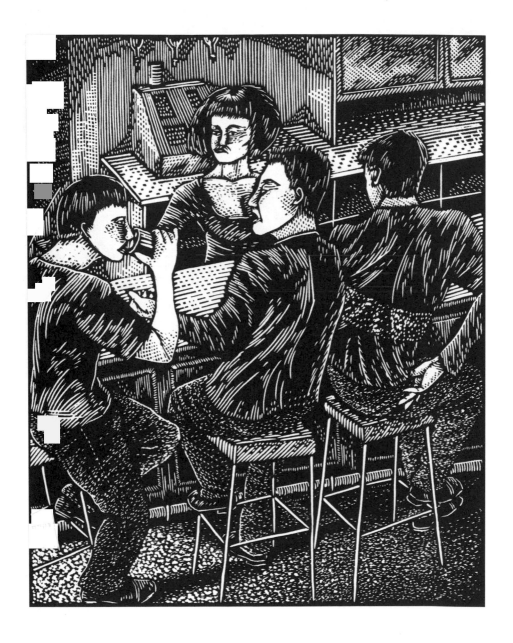

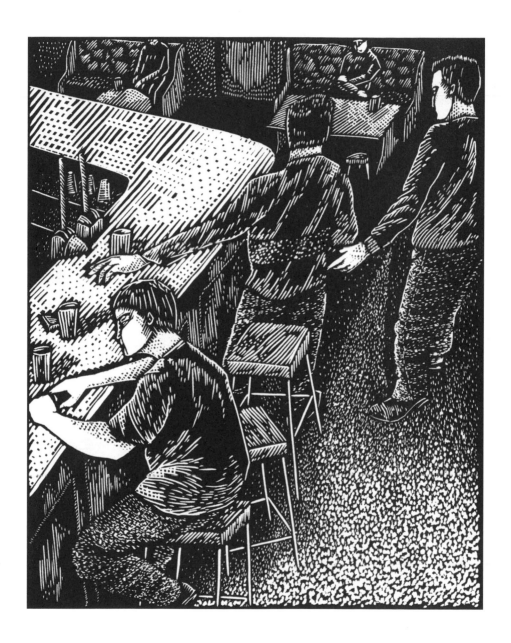

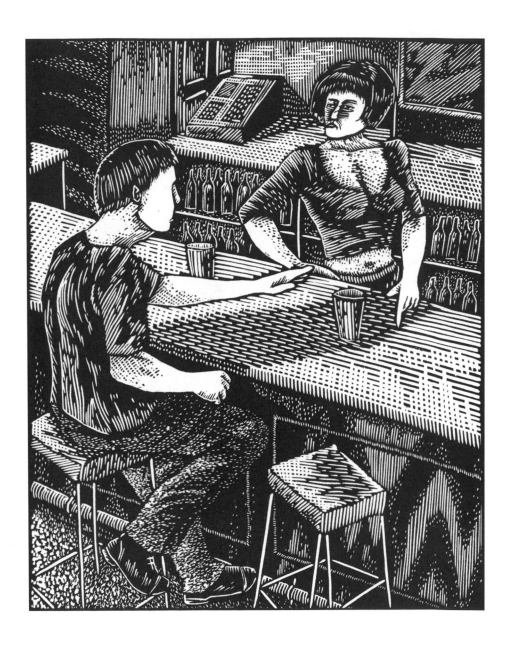

184

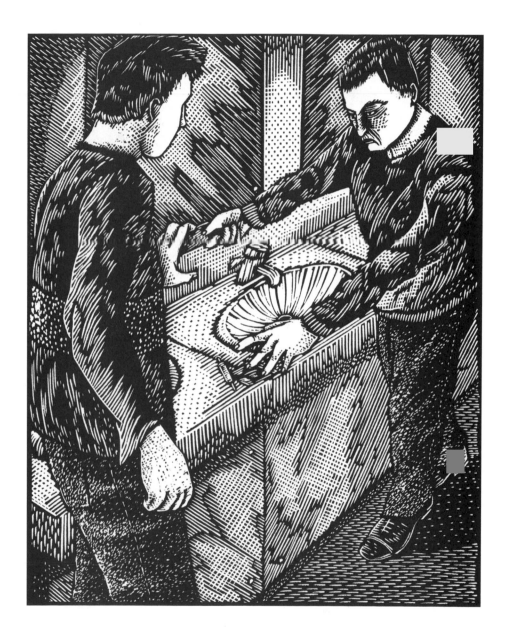

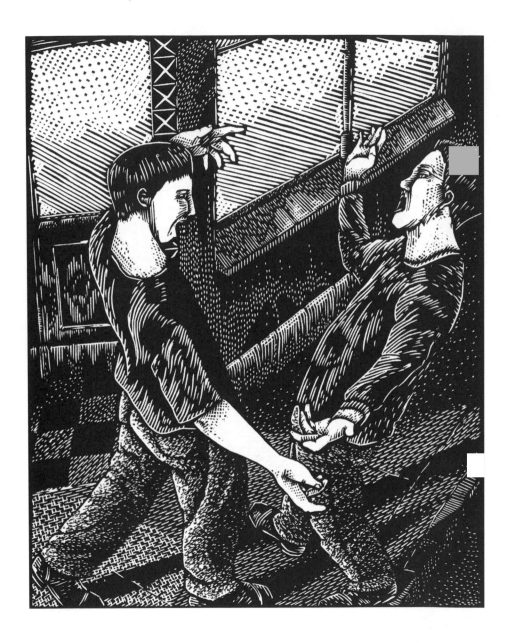

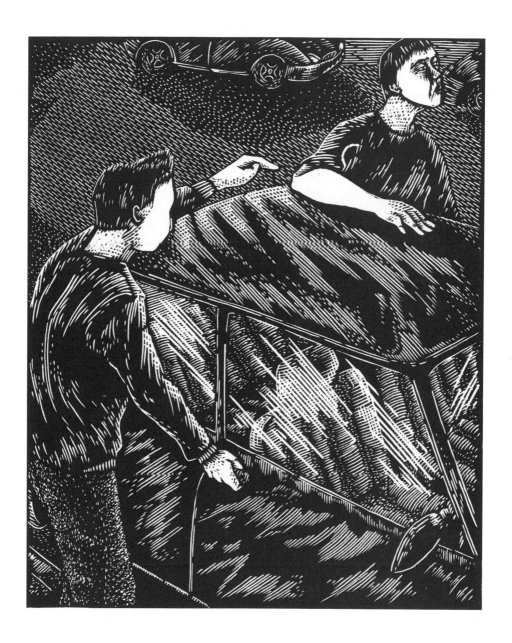

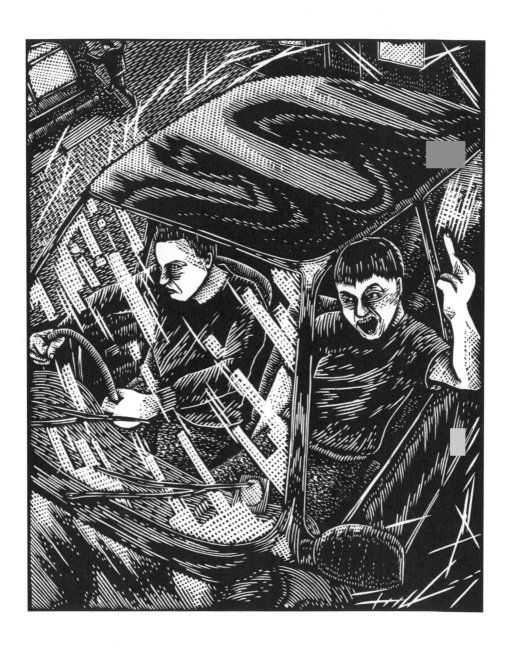

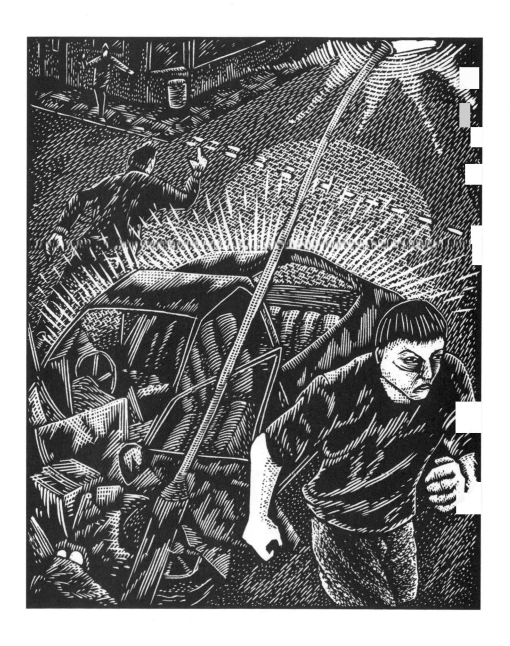

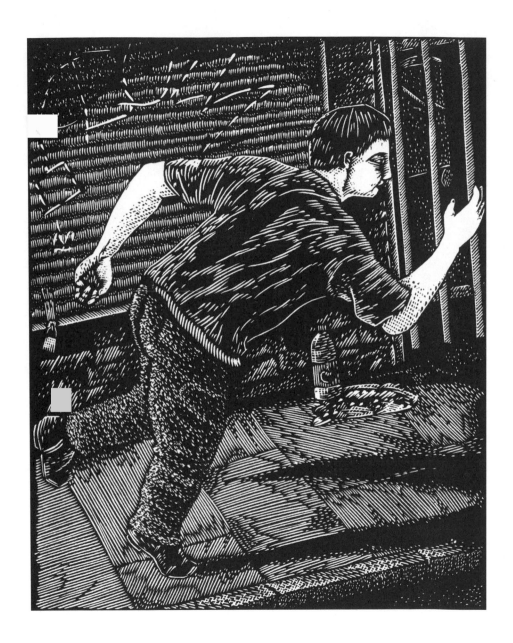

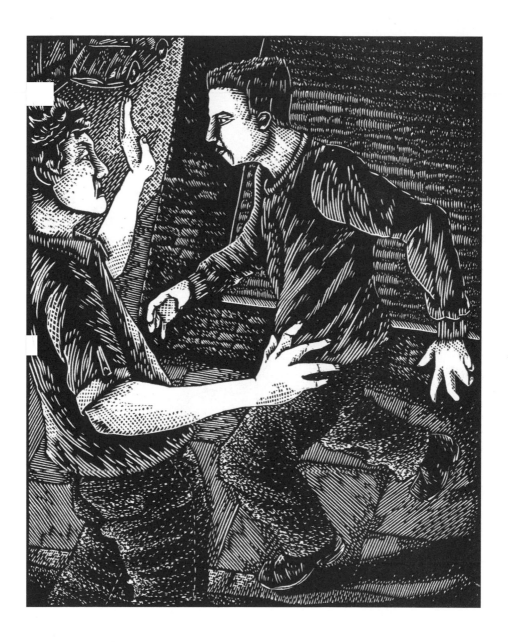

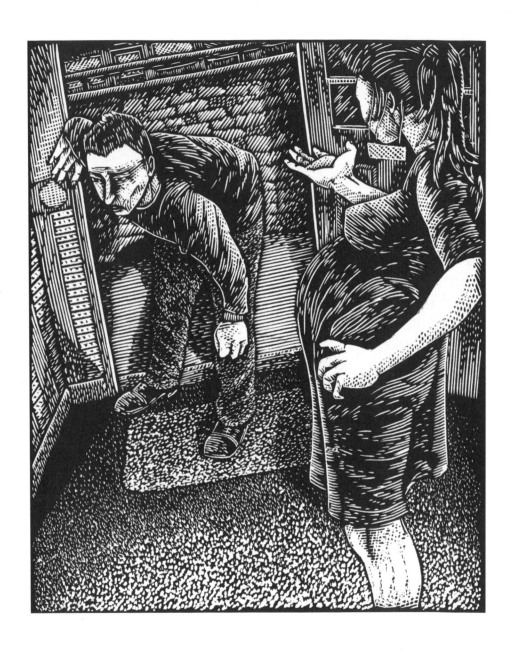

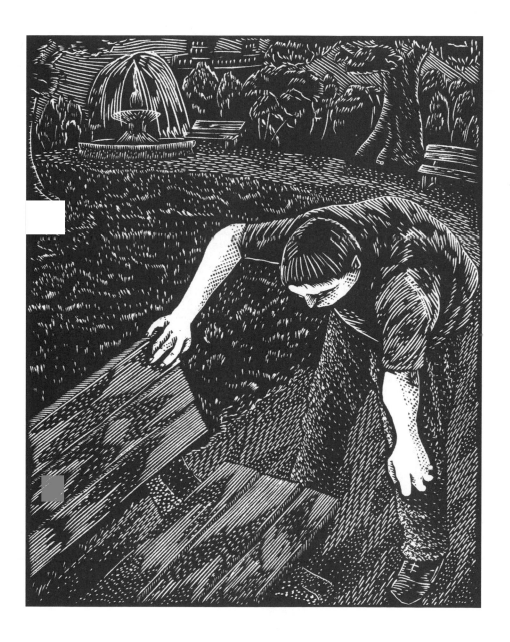

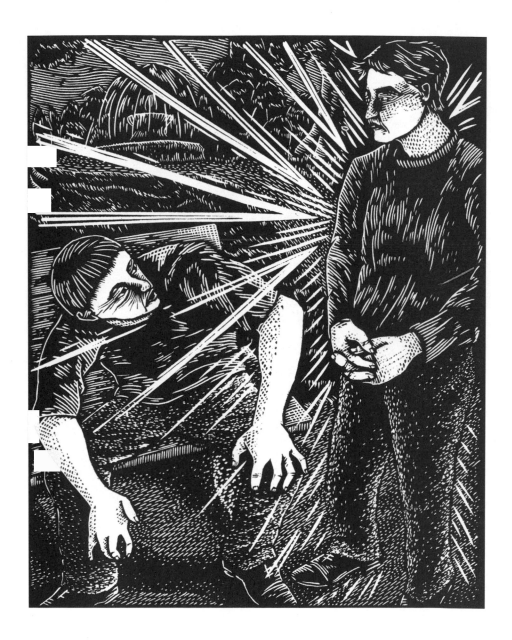

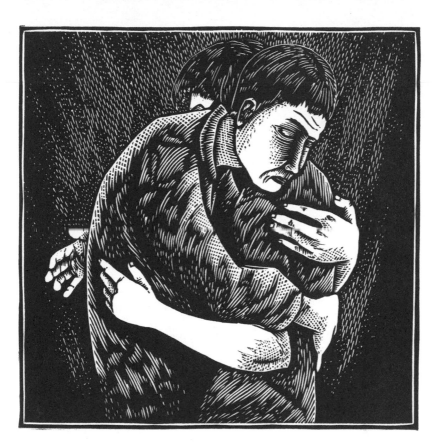

# CHAPTER
# TWELVE

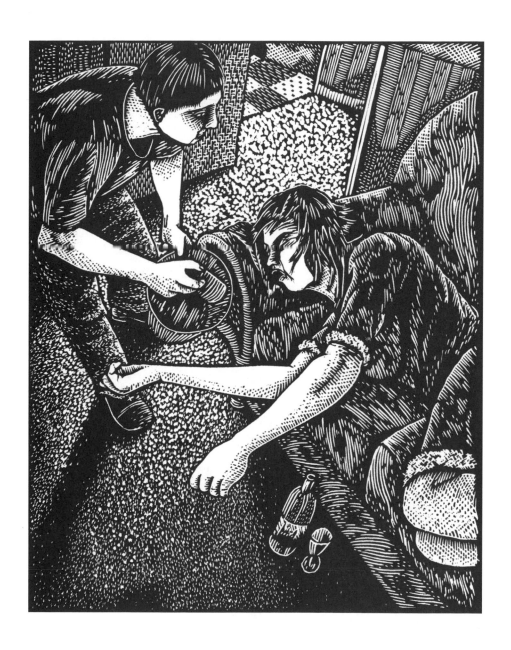

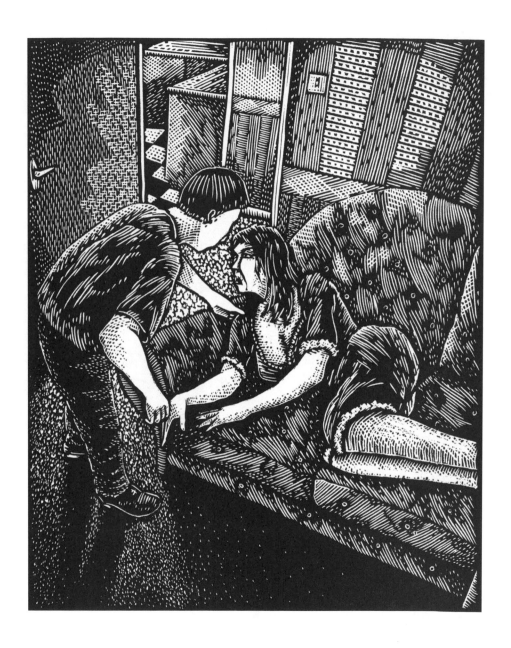

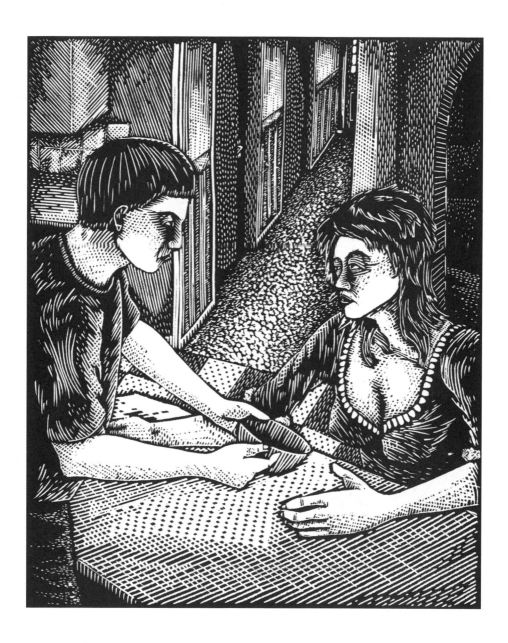

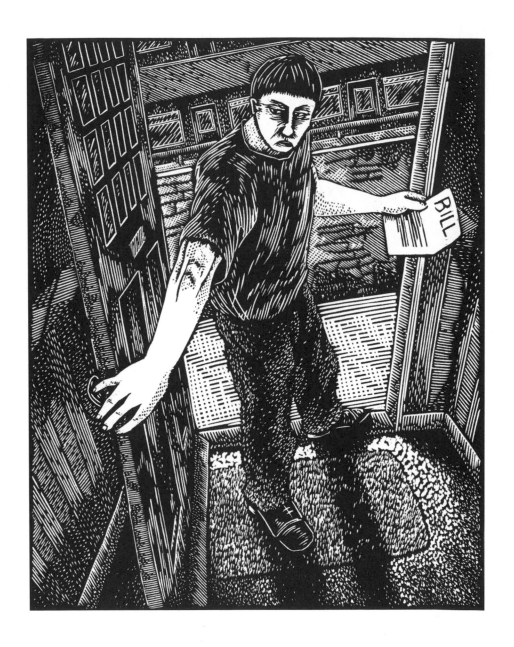

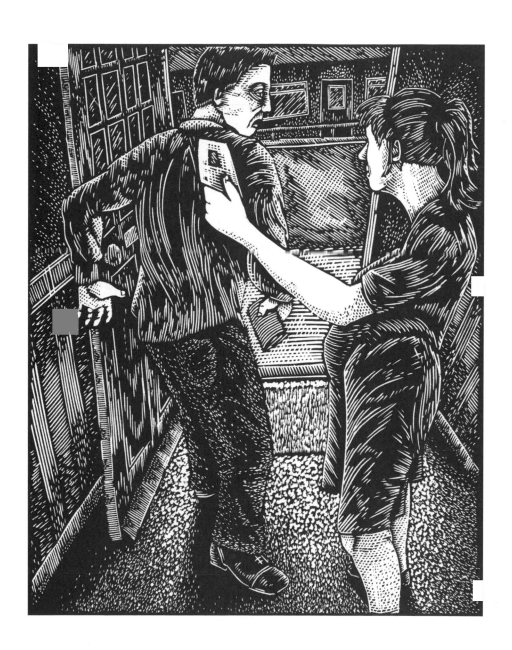

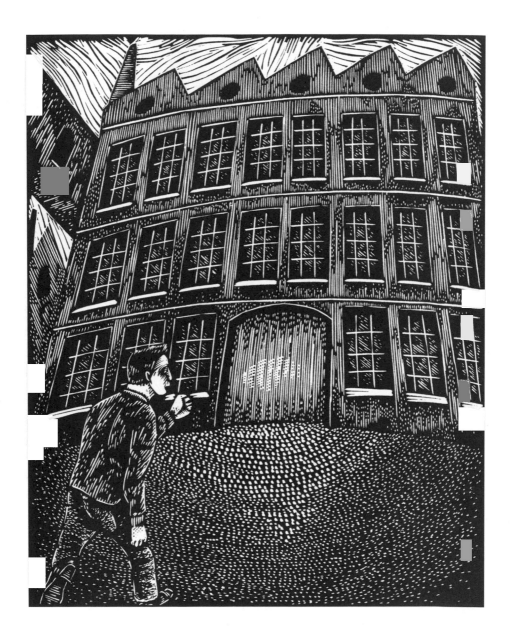

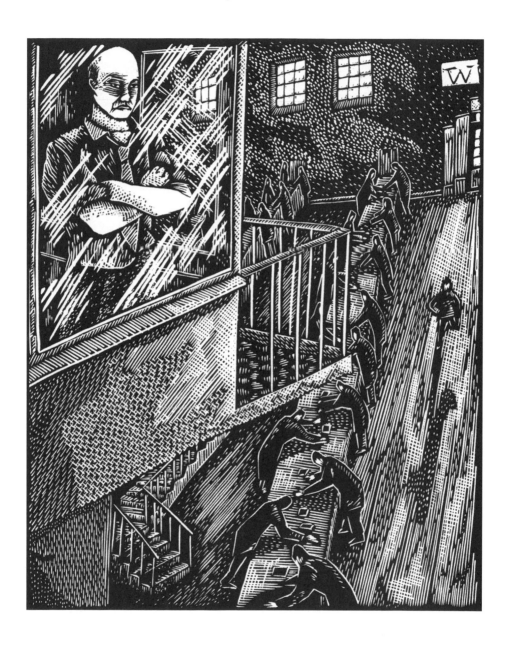

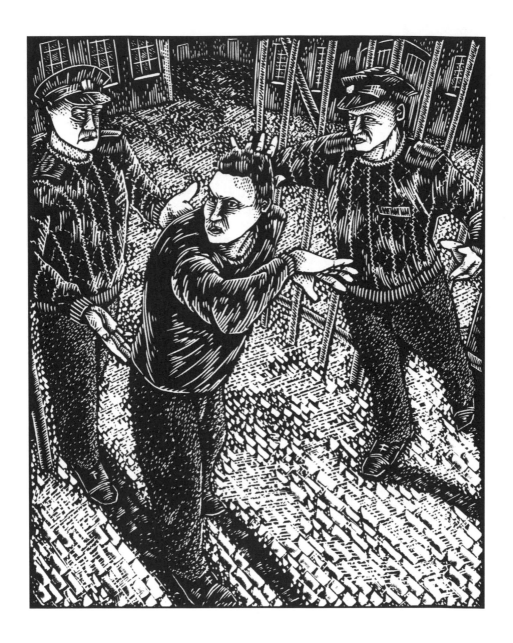

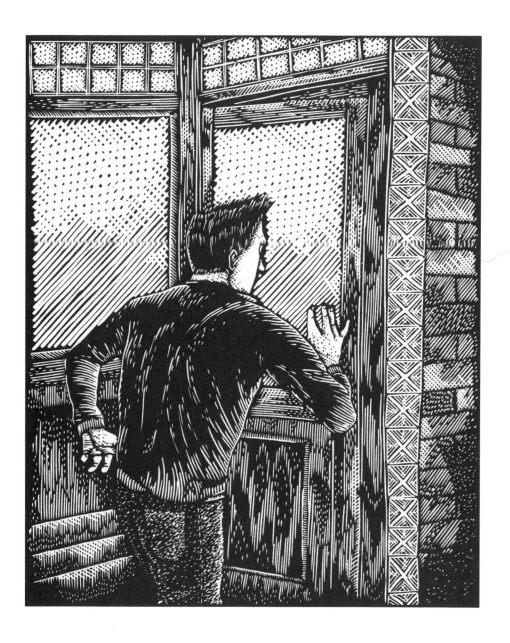

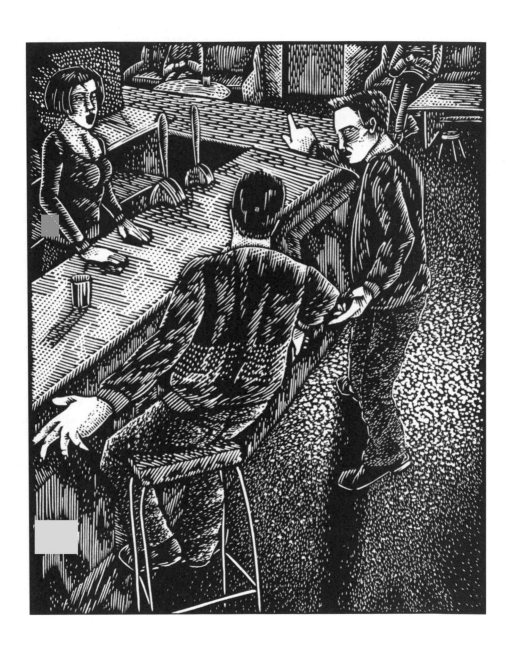

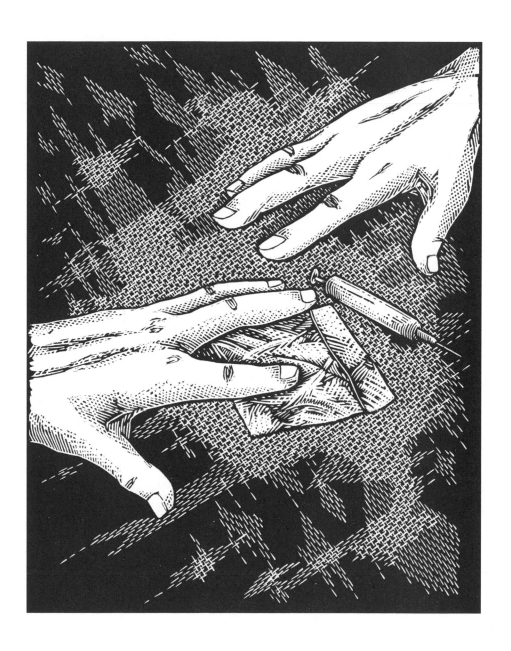

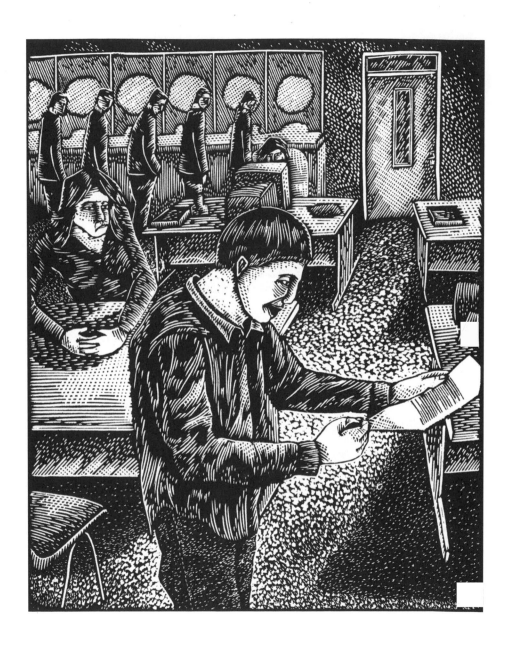

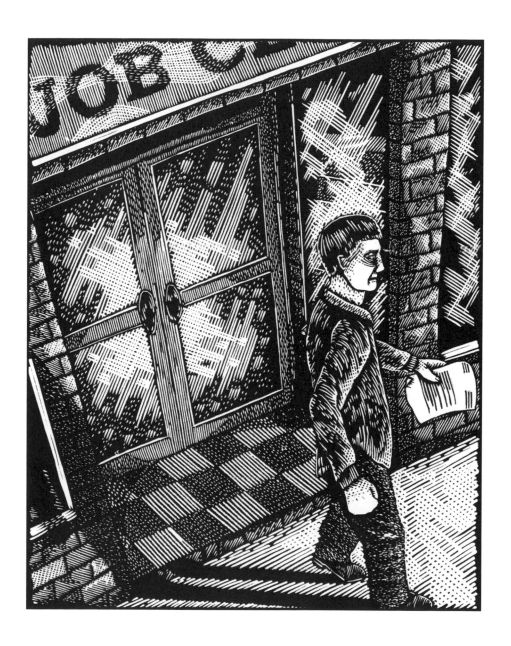

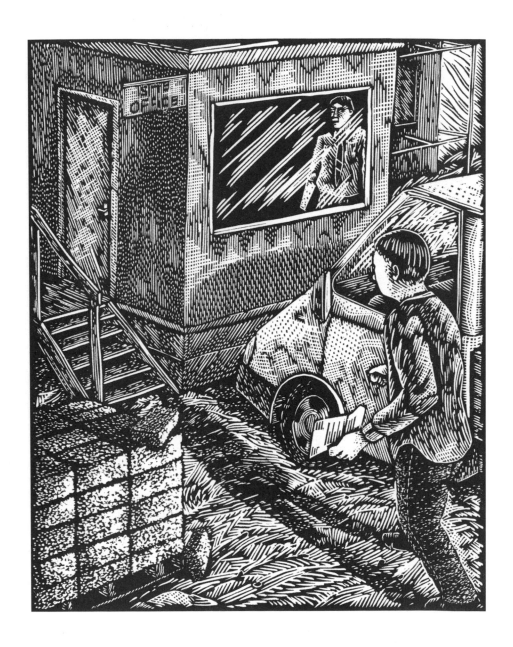

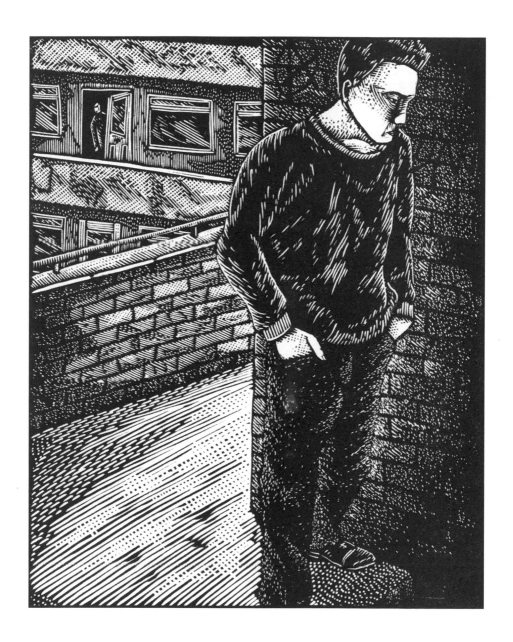

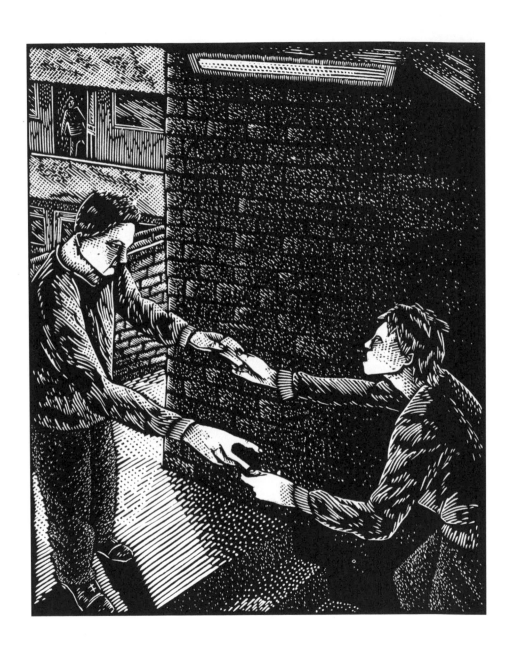

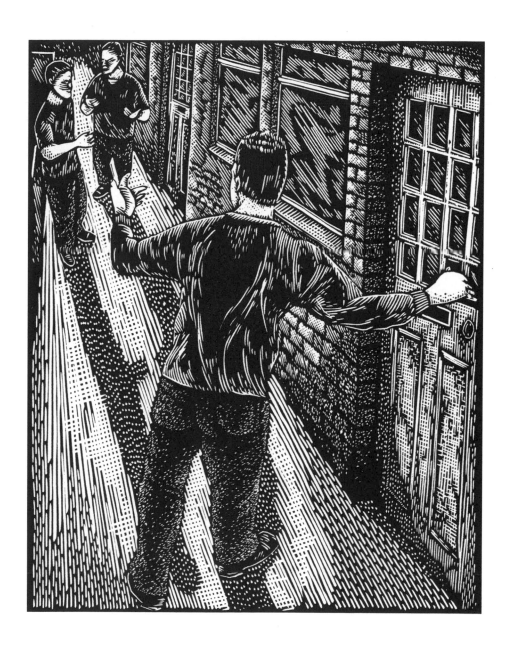

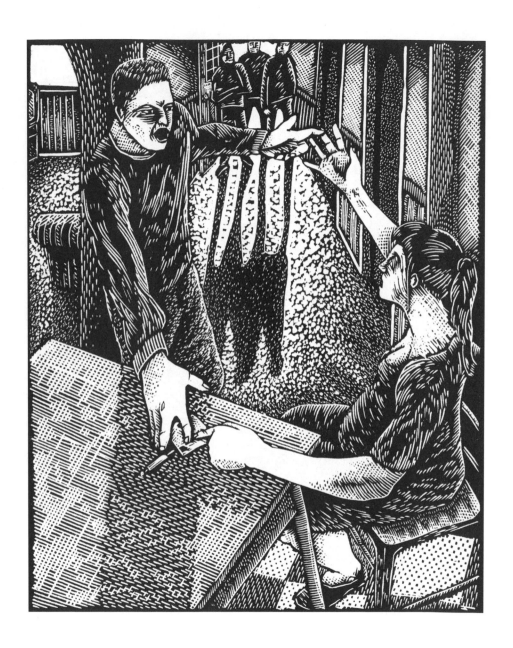

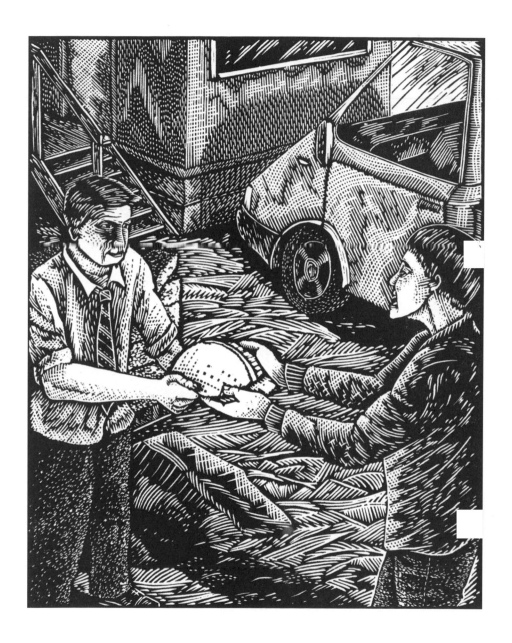

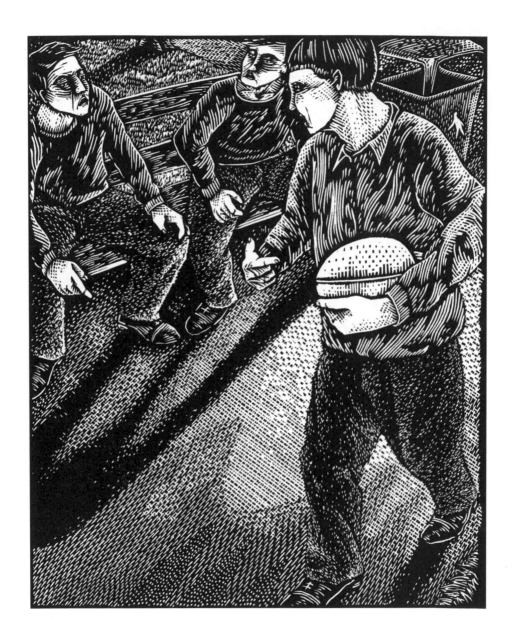

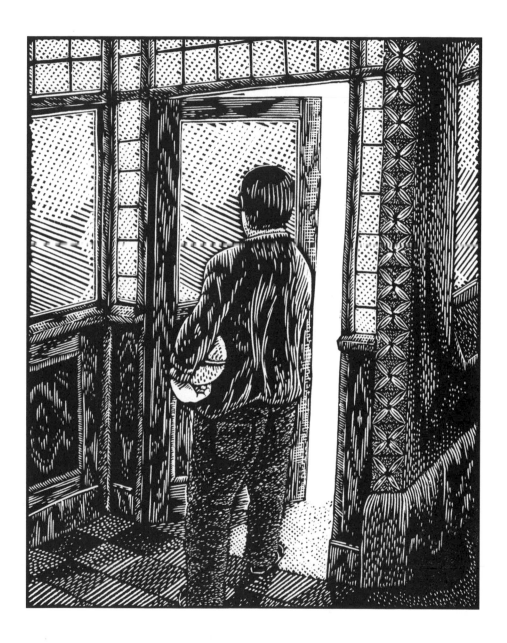

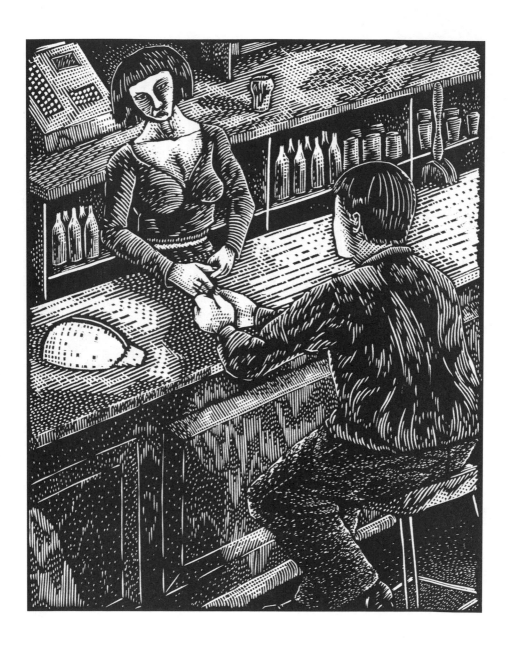

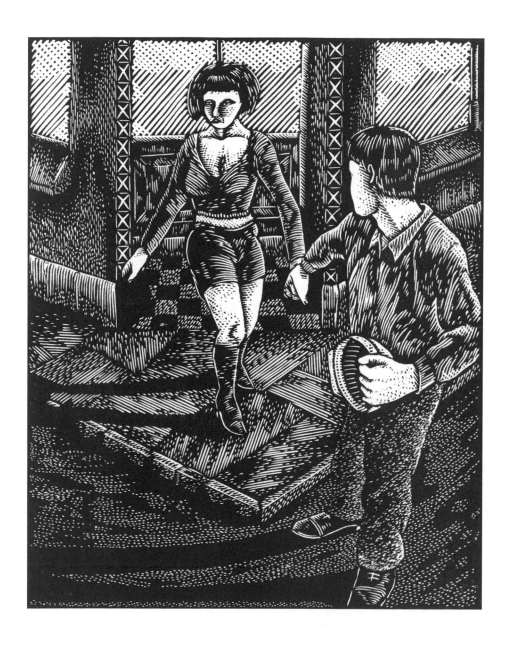

**WALKING SHADOWS** follows the tradition of novels in woodcuts where hand-cut images replace text as the narrative form. This particular "novel in woodcuts" builds on my own practice as a relief printmaker and is "engraved" rather than "cut" with gouges. This allows for a much finer image where greater detail can be achieved in a given space to create a sense of reality.

I have developed the narrative element within my relief print practice over many years. My work has completed a full circle back to my previous work as an animated filmmaker. Once again I am working with sequences of images, only this time the images are contained within a book rather than on a screen.

*Walking Shadows* was carefully planned to be completed within a set time. The images took two and a half years to create, and six months was spent planning, storyboarding, making a mock up, and drawing the images.

The process began with drafting the story and developing the characters. I drew a storyboard to lay out the narrative in images and took digital photographs for reference, from which the rough sketches were drawn. In turn I used these sketches to draw each final image. These drawings were then scanned, re-sized, printed out and finally transferred to blocks for engraving. The whole engraving process continued for a year, with each block taking one working day to engrave. The process was driven by targets and a strict schedule pushing me to complete the engravings on time. I was then ready to print.

*Walking Shadows* was inspired by my experiences while working for a small charity, where I ran a print and wood workshop. The principle was to help young people build confidence and self esteem through making art and craft items. Our overall aim was to support them in overcoming and dealing with various issues that had led to social exclusion. It was not unusual to find a negative cycle repeated through one or more generations in a family.

This experience led me to create a narrative using the ideas of being limited or excluded from life's opportunities by one's own expectations, circumstances, attitude, or education.

Whatever our background or education, our lives can turn on a dime. A rash decision, a heated argument, or a chance encounter can open doors or seal our fate. Only by trying to take constructive positive decisions do we stand any chance of fulfilling our true potential. Two people stand in a court: one, a convicted criminal; the other, a lawyer. How were they made?

Through the pages of *Walking Shadows* it is hoped that the reader will be able to extract the basic narrative from the images and so begin to construct their own meaning, take ownership and make their own choices: a metaphor for life, perhaps? By questioning circumstances, outcomes, and by considering others, we may find a decent path through life.

Whatever age, background, or language you have, pictures speak to everyone. So thanks to those of you who turn these pages, and if this is your first novel without words, there are many more gems to be discovered.

Neil Bousfield
Gloucestershire, England